To Pat + Joan
Here it is

John Sullivan

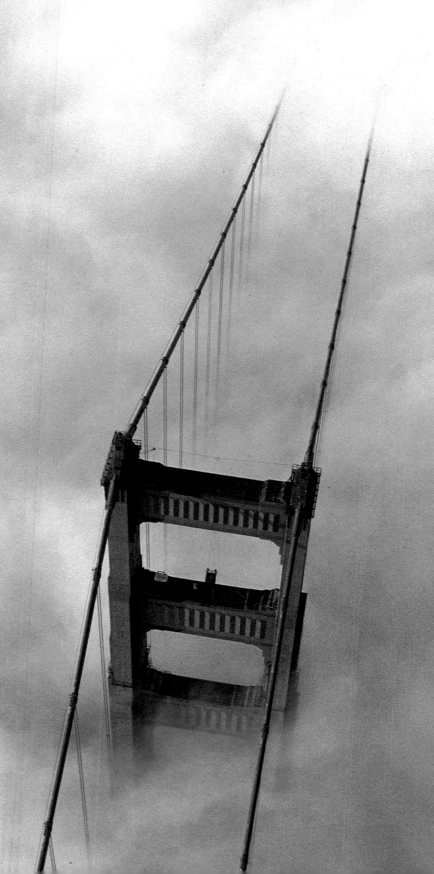

SAN FRANCISCO

SAN FRANCISCO

The City's Sights and Secrets

Text by Leah Garchik

CHRONICLE BOOKS
SAN FRANCISCO

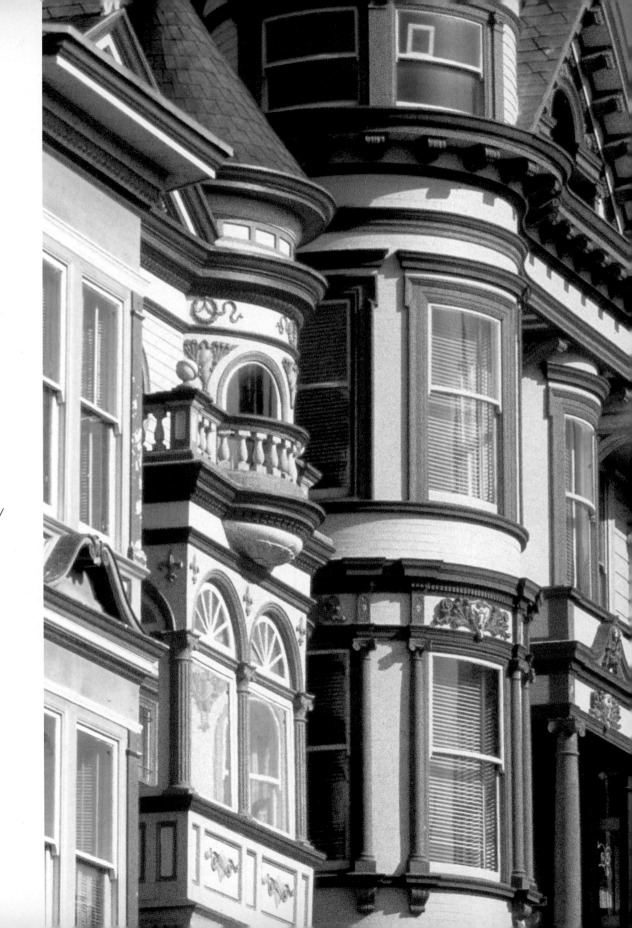

Right: Victorian houses

Page 6, top: The Golden Gate Bridge;
bottom: Market Street

Page 7, top: The Embarcadero with the Bay Bridge;
bottom: A California Street cable car

Compilation copyright © 1995 by Chronicle Books.
Text copyright © 1995 by Leah Garchik.
See page 120 for photographic copyright information.
All rights reserved. No part of this book may be reproduced without
written permission from the publisher.

Printed in China

Book and cover design by John Sullivan and Dennis Gallagher/
Visual Strategies, San Francisco.
Photo research and photo editing by Ruth Hagopian and Kina Sullivan/
Visual Strategies, San Francisco.

Library of Congress Cataloging-in-Publication Data

Garchik, Leah.
San Francisco : the city's sights and secrets/text by Leah Garchik.
 p. cm.
 ISBN 0-8118-0942-0. —
 ISBN 0-8118-0917-X (pbk.)
 1. San Francisco (Calif.) —Pictorial works. I. Title.

 F869.S343G37 1995 94-42301
 979.4'61053'0222—dc20 CIP

Distributed in Canada by
Raincoast Books
8680 Cambie Street
Vancouver, B.C. V6P 6M9

10 9 8 7 6 5 4 3 2 I

Chronicle Books
275 Fifth Street
San Francisco, CA 94103

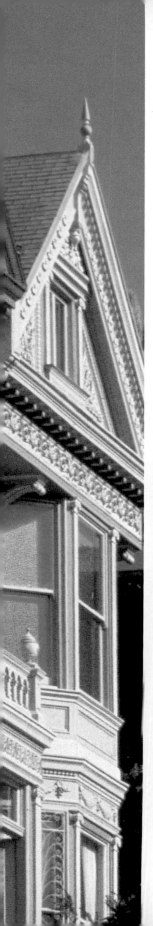

CONTENTS

INTRODUCTION

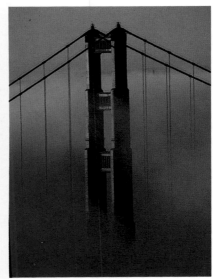

A cable car ride is always a party, with whoops and hollers and brightly dressed revelers pressing close, but there are many level-headed travelers who refuse to accept San Francisco's hospitality. They have very definite reasons for staying away from the city: "Why would anyone go there?" they ask. "If the earth were to shudder and heave again, why, San Francisco could break right off and float away into the Pacific. You wouldn't catch me there."

The science is all wrong, but perhaps the instinct is right. This city, built on fantasy rather than bedrock, isn't a place for sensible people. It's a place for explorers, for prospectors, for optimists undaunted by fear and undeterred by reality.

The Forty-Niners didn't dream of factories or modest settlements; they dreamed of gold, elusive and precious, and uncountable riches. They prized their visions long after giving up hopes for their fruition, long after glittering fantasies about tomorrow had become anecdotes about yesterday.

Most came away from the Gold Rush with not much more than their memories. If they had been more realistic, they'd have left this place in 1906, for the great earthquake was a seismic attempt to pound more sense into their heads.

They stayed, knowing it could happen again,

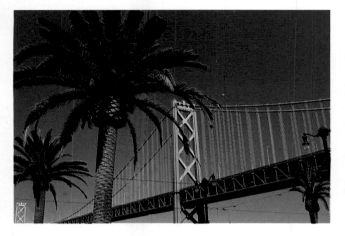

that anything could happen. Philosophically, the possibility of breaking loose hovers over every moment. It's exactly that sense of uncertainty—promise or threat, depending on one's point of view—that has always set San Francisco apart from other places.

In *On the Road*, Jack Kerouac described a night in San Francisco after traveling cross-country: "I never saw such crazy musicians," he wrote. "It was the end of the continent. They didn't give a damn."

The city's spirit of adventure and anticipation, undimmed after 150 years, mirrors the lay of the land. Ambling through the streets, the explorer is apt to play hide-and-seek with the horizon, which is in the habit of disappearing behind a hill or burrowing under a blanket of fog wrapped around the edge of the bay. It's usually difficult to see what lies directly ahead, and it's impossible to see what's off in the distance.

Only at the crest of one peak do you discover that there's another climb ahead or that the few blocks to the site on the map are an easy stroll downhill. Only after waiting out the morning fog, your trembling fingers wrapped around a steamy cappuccino, are you allowed the privilege of unwrapping your scarf in the sunshine.

Will the skies clear? Speculation is usually inaccurate, and the residents learn to relish the unpredictable. In San Francisco, you never know what's next.

—*Leah Garchik*

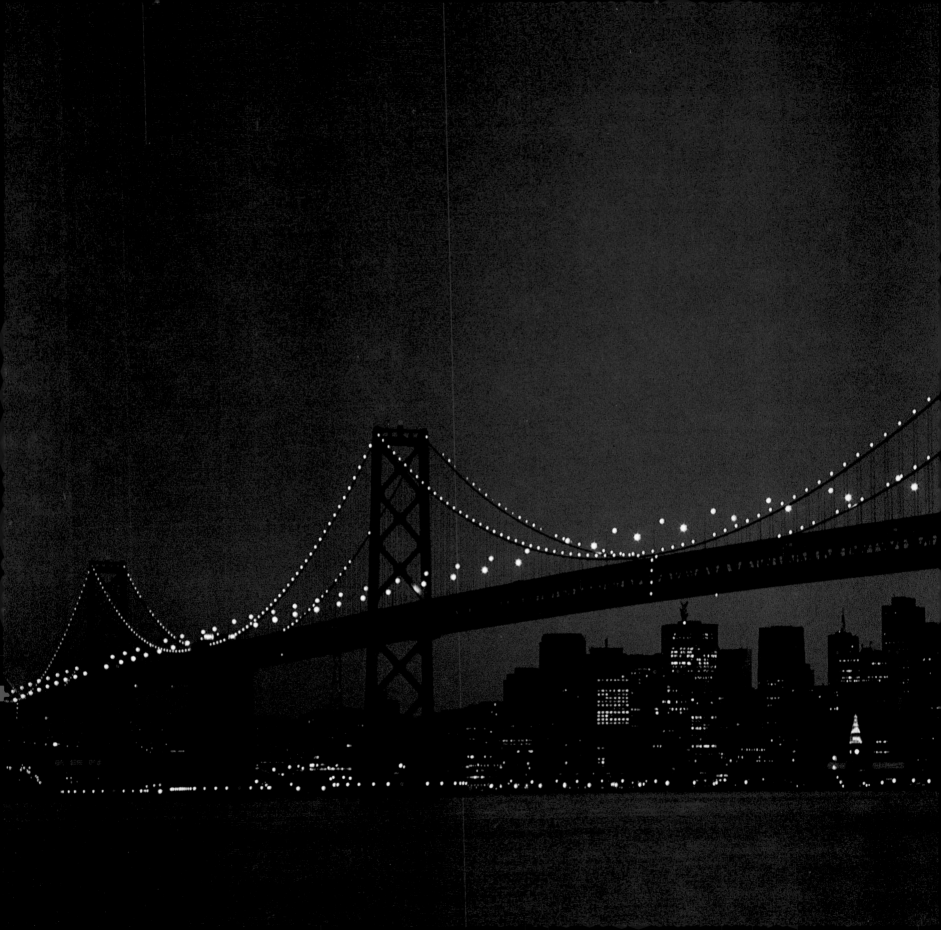

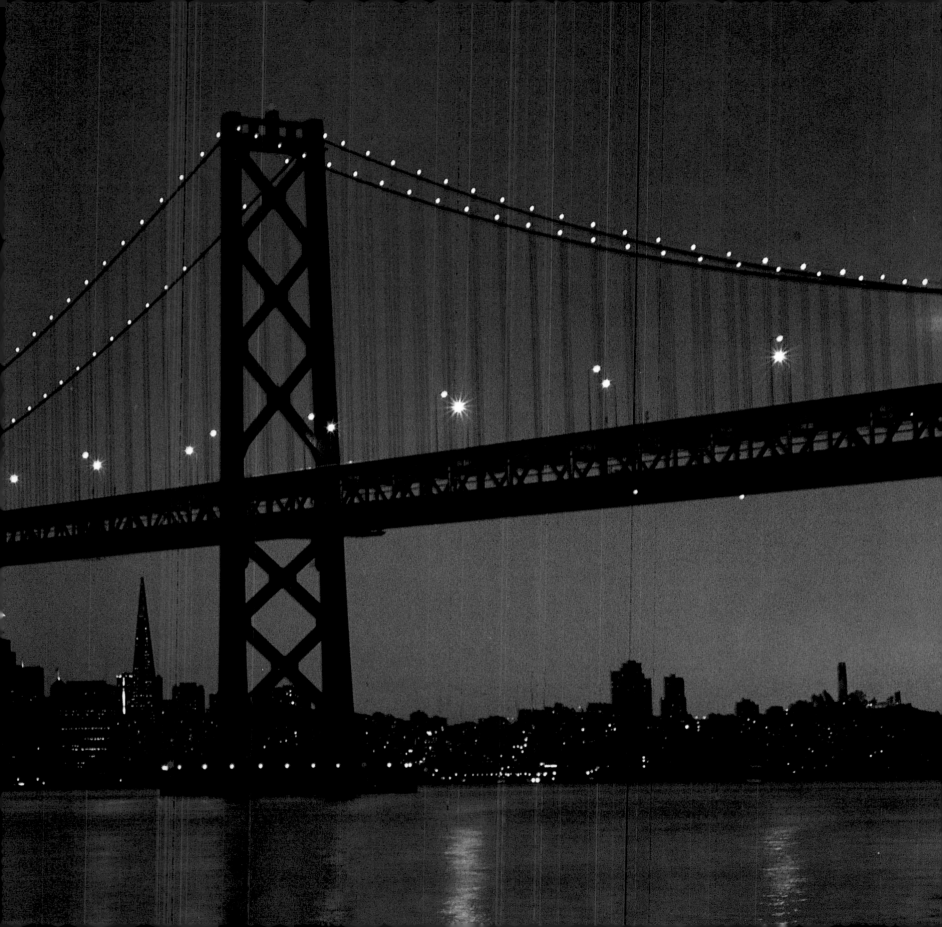

DOWNTOWN

Downtown San Francisco was once a formal place, where men in double-breasted suits doffed their fedoras at ladies who wouldn't venture onto its sidewalks without hats and gloves. Today, bicycle messengers in blue jeans line up with men in baseball caps and women in suits at outdoor cappuccino stands, and cable cars lurch past neat rows of skyscrapers.

The downtown area is a basin nestled among residential hills. Tree-lined Market Street, its main thoroughfare, shoots from the eastern waterfront through a corridor of office towers, past the Union Square shopping district, to Civic Center, with its wedding-cake City Hall, museums, and symphony and opera houses.

PREVIOUS PAGES

Commuters were so delighted by the looks of lights strung across the cables of the Bay Bridge for its fiftieth anniversary celebration that they donated an extra quarter to the toll to make the lights permanent.

RIGHT

The variety of office buildings crowded into downtown includes graceful relics of the past, hard-edge models of the International Style, and ornamented examples of the post-modernist era.

The Transamerica
Pyramid, built in 1972,
features 53 usable stories
and a 220-foot spire that
houses machinery for
ventilation and heating.
The geometric shapes at
its base were designed for
added strength in case of
earthquakes.

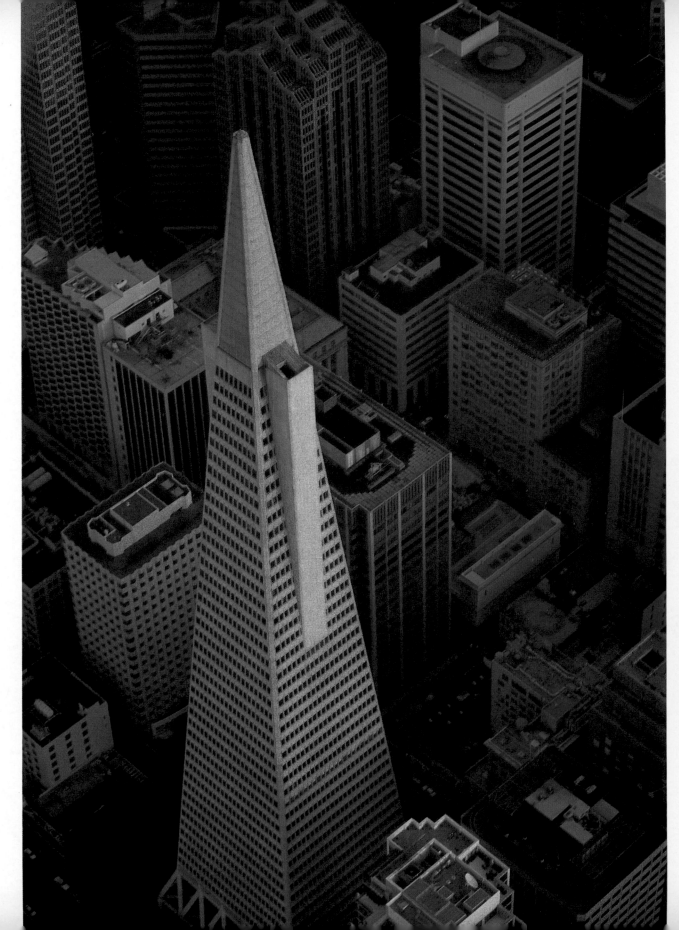

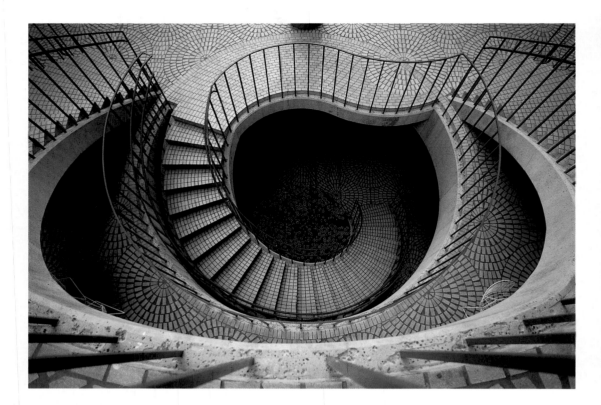

A staircase in the Embar-
cadero Center, historic
light posts along Market
Street, and the concourse
of the Federal Reserve
Building are evidence of
the grace and wit with
which designers from past
to present have approached
civic projects.

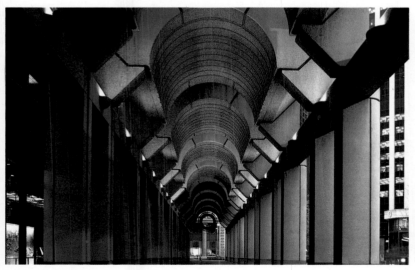

BELOW

Union Square, in the heart of downtown San Francisco, is ringed by the city's best department stores. Since the days of the Gold Rush, the city's financial success has been derived from commerce rather than industry. Fluctuations in the national economy can have visible results on even the most elegant city streets.

RIGHT

The monument in the middle of Union Square, which honors Admiral Dewey's victory at Manila Bay during the Spanish-American War, was dedicated by President Theodore Roosevelt in 1903.

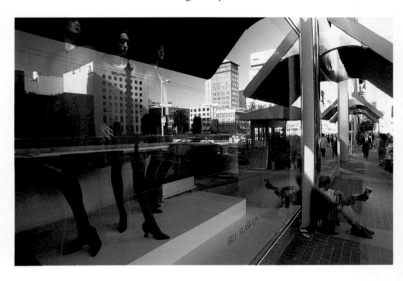

RIGHT

The Tadich Grill, the oldest restaurant in California, is known for keeping up traditions, from its fresh-fish cuisine to its dignified decor dominated by polished brass and starched linen.

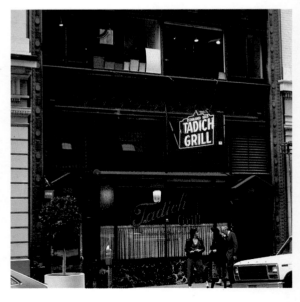

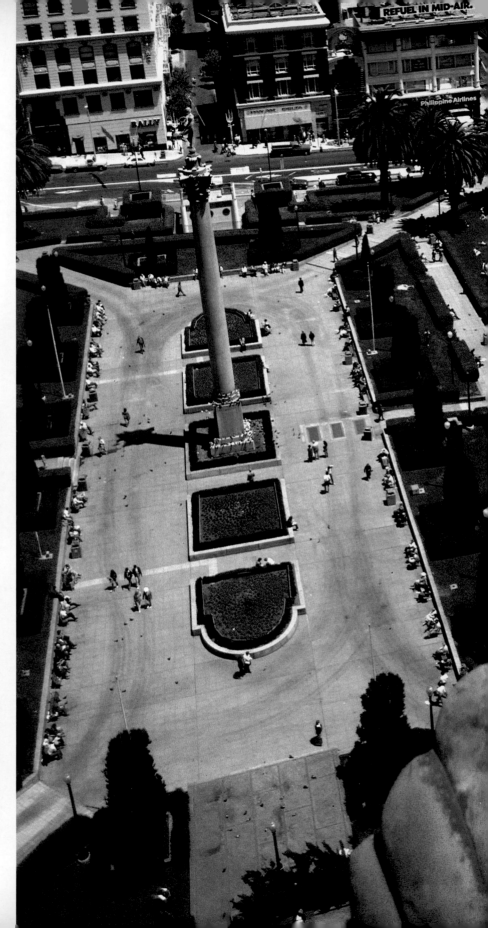

14

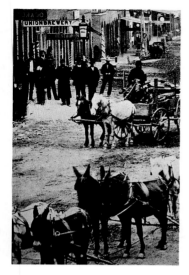

The Gold Rush

In 1848 James Marshall, who was building a sawmill for Augustus Sutter in the foothills of the Sierra Nevada, found flecks of gold in the American River. By 1849, news of his discovery had attracted swarms of gold-hungry adventurers who surged westward through the Rockies, traipsed northward from the swamps of Panama, and looped the loop around Cape Horn in a ragtag armada of ships.

By 1849, San Francisco's population had grown from 900 to 25,000, and San Francisco Bay was dotted with the masts of 500 abandoned ships.

There were the Forty-Niners and, of course, there were also those who had come to make their fortunes from the fortunes of the Forty-Niners: reporters, importers, gamblers, sailors, assayers, laborers, doctors, and merchants peddling drugs, liquor, women, and the tiny plots of real estate into which the city was being divided.

There were Chinese, Mexicans, and Australians, and an array of newspapers in languages for all.

San Francisco was a city of surprises, a place where a man could set aside his pickax one day, and be fitted for a silk vest the next.

Yerba Buena Gardens is host to a variety of activities, including outdoor concerts coinciding with such events as a citywide Filipino-American Exhibition, Native American Crafts Day and a Lesbian and Gay Youth celebration.

Special events often include the exhibit of temporary outdoor statuary. Nearby, the Marriott Hotel accommodates thousands of visitors and is linked, by passageways and meeting rooms beneath the gardens, to the Moscone Convention Center.

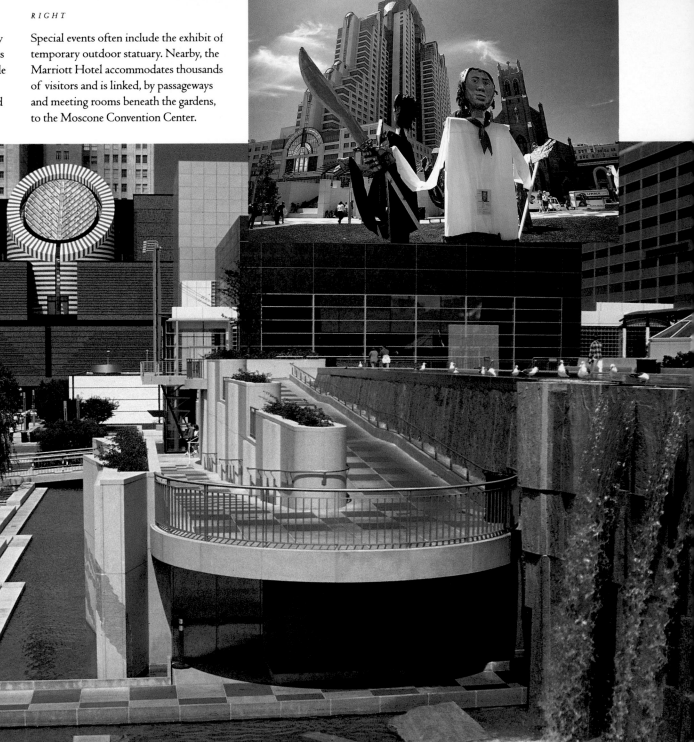

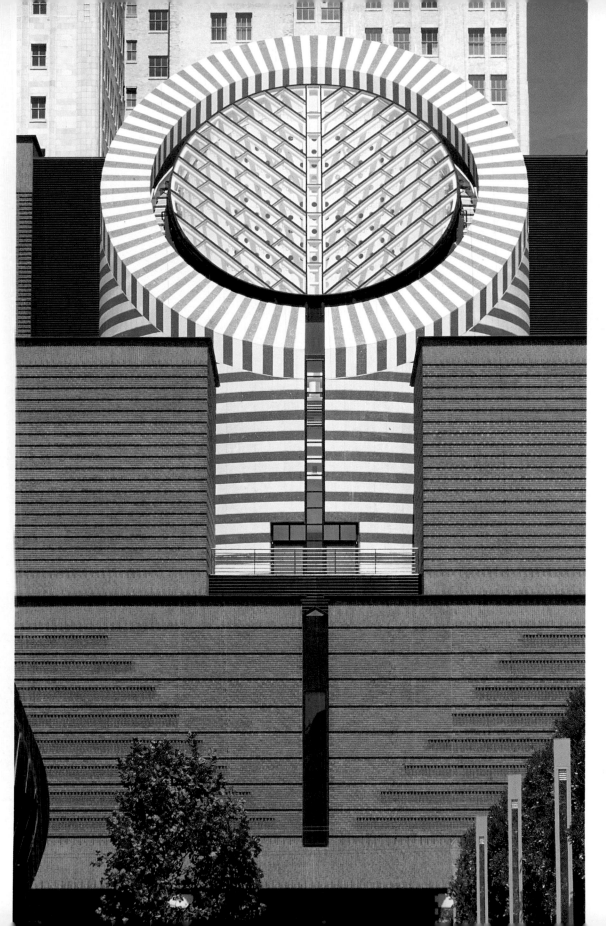

The new Museum of
Modern Art, designed by
Mario Botta to house a
collection emphasizing
the work of 20th century
California artists, contains
50,000 square feet of
gallery space. The museum
is at the edge of the Yerba
Buena complex, which
includes gardens, a memorial
to Martin Luther King, Jr.,
a convention center, galleries,
restaurants, and a theater.

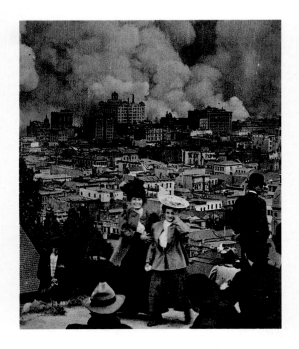

1906

At 5:16 A.M. on April 18, 1906, the earth heaved a tremendous shudder that stopped dead the clock on the tower of the Ferry Building at the foot of Market Street. The initial shake lasted 48 seconds, an endless three-quarters of a minute for terrified citizens thrown from their beds as the walls of their houses swayed, twisted, and then crashed into splinters.

When the ground stopped trembling, ruptured gas lines, crossed electric wires, broken chimneys, and overturned stoves caused fires that roared through-out the city. Ruptured water mains deprived firefighters of a means to quell the flames.

For three days and three nights, San Franciscans watched their gleaming city burn to smoldering embers. In all, 28,000 structures were destroyed.

Still, most survivors — adventurers who had moved west with optimism and energy — refused to let their ambitions die in the ashes. "After what we have gone through," one wrote, "nothing is too difficult for us to accomplish."

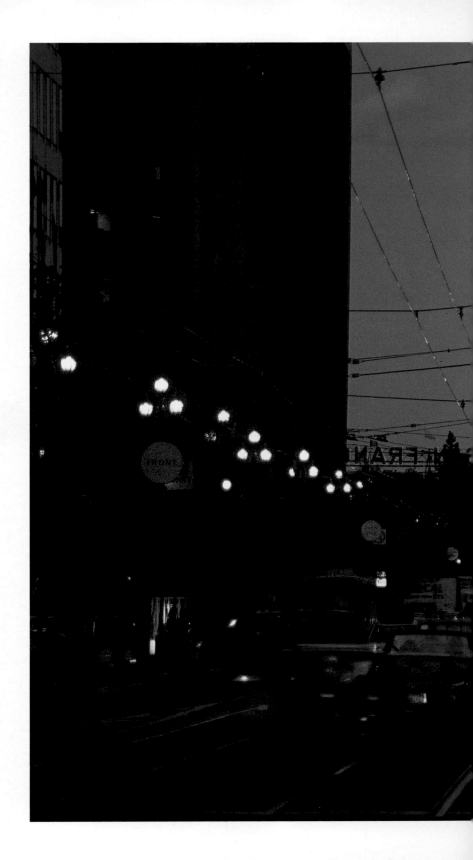

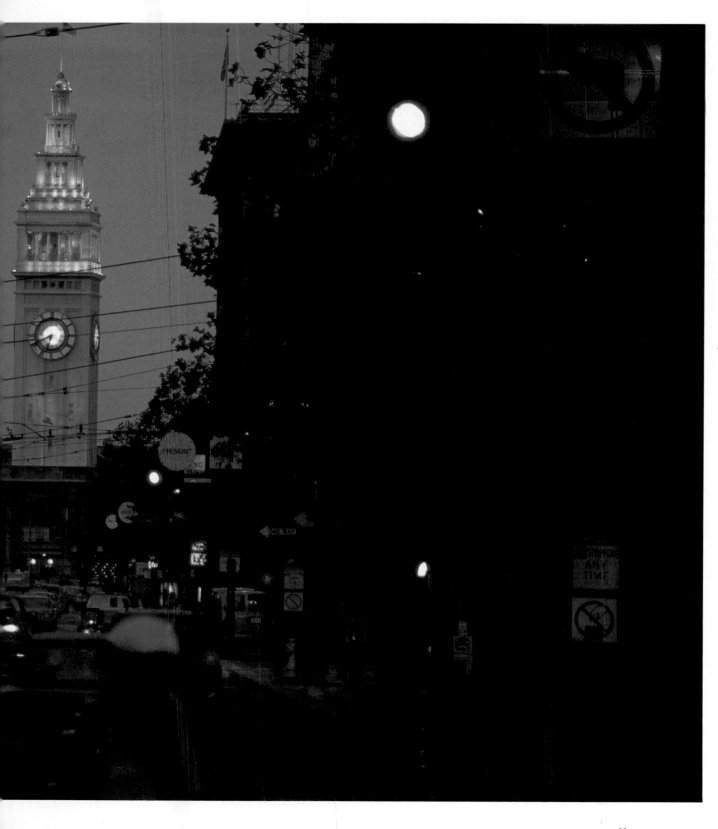

Before the Golden Gate Bridge was built, the tower of the Ferry Building at the foot of Market Street, modeled after the bell tower of the Cathedral of Seville in Spain, was considered the symbol of San Francisco. People and goods from across the continent and Europe flowed from the ferries down Market Street to every corner of the city. Nowadays, a farmer's market takes place every Saturday on the plaza in front of the building.

19

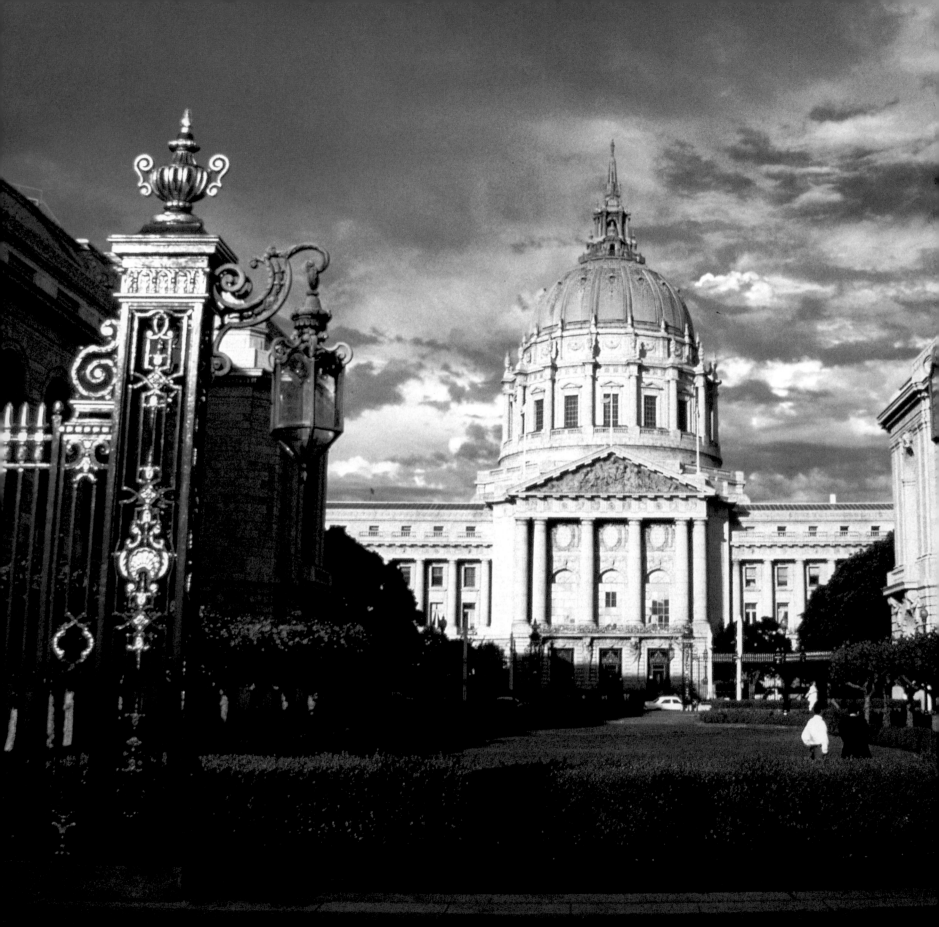

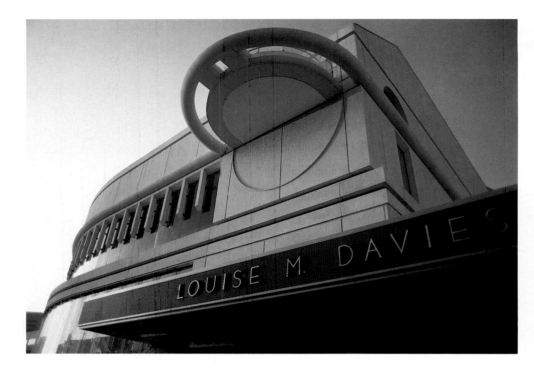

ABOVE

Davies Symphony Hall was
a gift to the San Francisco
Symphony from philan-
thropist Louise M. Davies
in 1980. Its architects,
Skidmore, Owings &
Merrill, also designed the
state building at the
opposite corner of Civic
Center; the rounded
facades of the two build-
ings were planned to be
complementary. Like
Davies Hall, many of the
finest buildings in the city
were built at the behest of
its most prominent citizens.

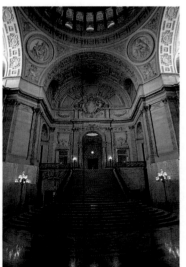

LEFT

The city's majestic
French Renaissance–style
City Hall was dedicated
in December 1915. The
restoration of the ornate
structure, which was
damaged in the 1989
earthquake, is one step
in a master plan of Civic
Center renovations
begun in the wake of
that disaster.

LEFT

The heart of the Civic Center faces west onto Franklin Street. From left: the War Memorial
Veterans Building, City Hall, and the War Memorial Opera House. Elsewhere in the complex
are the Bill Graham Auditorium, Brooks Hall exhibition center, Louise M. Davies Symphony
Hall, federal and state office buildings, the old library (slated to become the Asian Art
Museum), and the new main branch of the San Francisco Public Library.

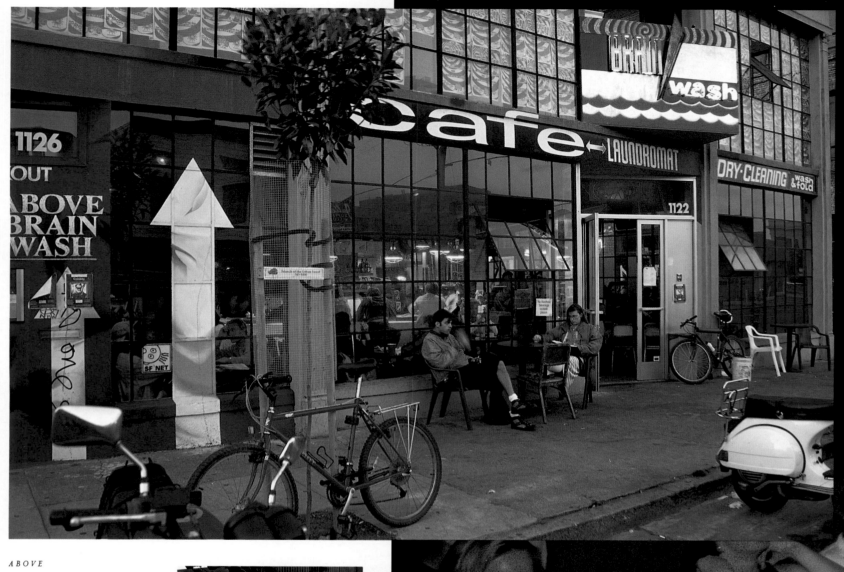

ABOVE

The Brainwash, a combination laundry, bar, restaurant, and cabaret, opened in 1990 to serve those in need of bright lights, heavy metal, and clean socks.

RIGHT AND FAR RIGHT

Artists, musicians, dancers, and fans of theater, poetry, and, most of all, loud music, gather at trendy clubs in the city's South of Market area.

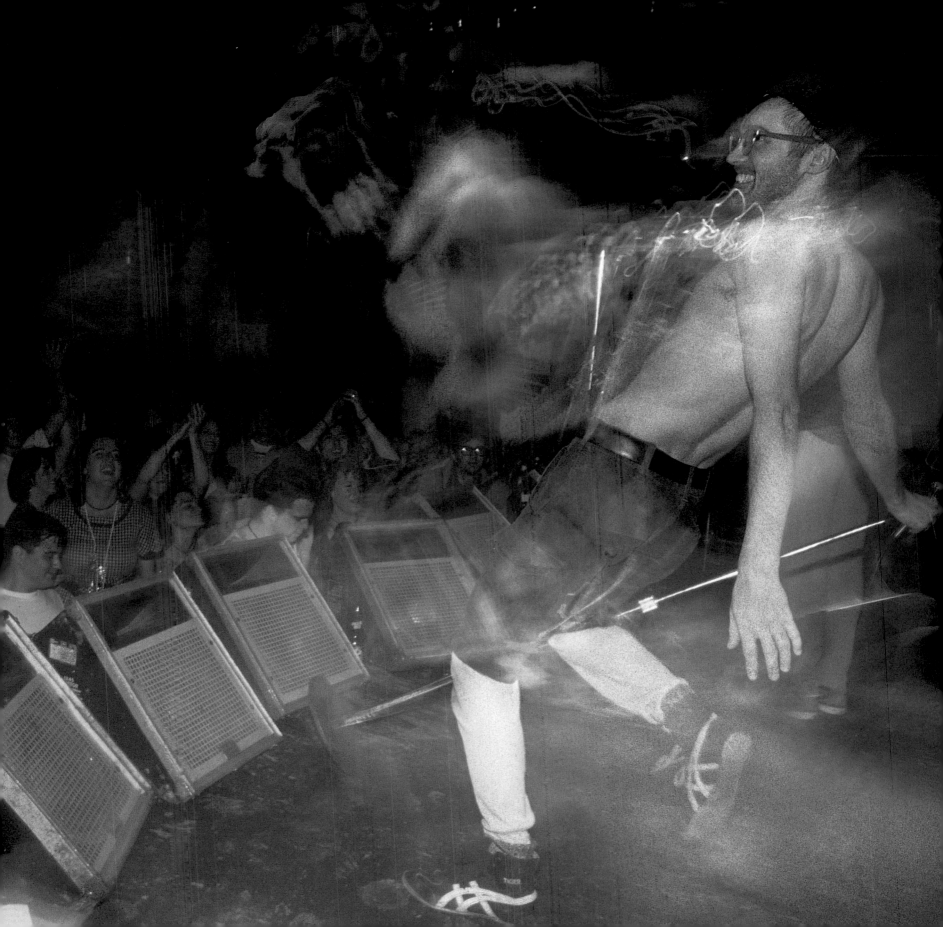

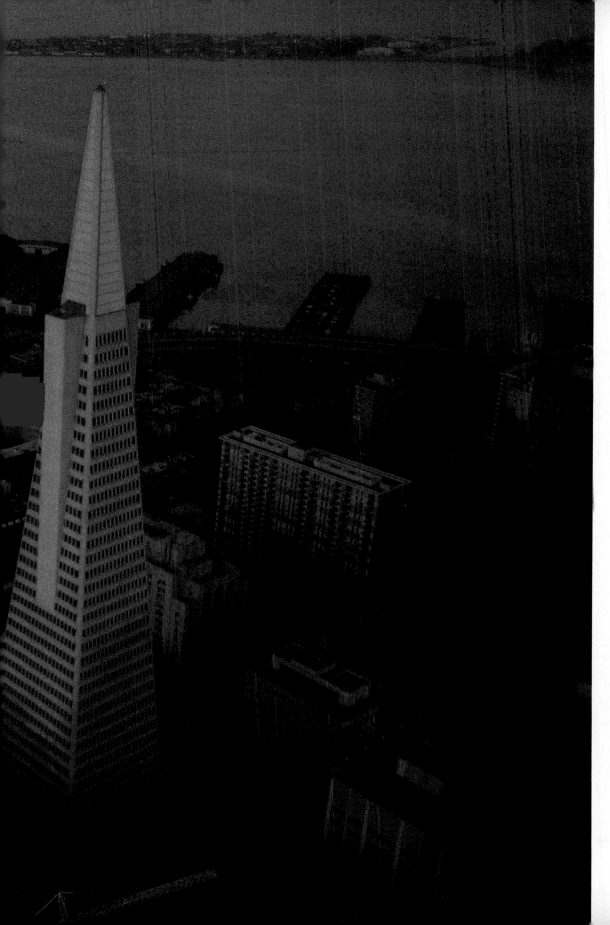

THE WATERFRONT

The eastern waterfront offers some of the city's best views and what should be its best weather, thanks to hills to the west that form a natural barrier against the elements. This theory may be greeted with skepticism by visitors snapping up sweatshirts at Pier 39; commuters bundled up to ride the ferries to work from Marin County; and ballplayers at Candlestick Park, where the wind once blew a visiting pitcher off the mound in the middle of an All-Star game.

The waterfront was once a bustling working harbor, but most commercial shipping has moved across the bay to more modern facilities in Oakland. The waterfront skyline is dominated by the outline of the nearby Transamerica office tower.

When the Embarcadero freeway was razed because of damage from the 1989 earthquake, landscapers' plans to place a row of full-sized palm trees along the new promenade enraged environmental purists, who argued that the palms aren't native plants. They lost the argument.

LEFT

Along the Embarcadero's Promenade, historic photographs and quotations are imprinted on 15 enameled porcelain pylons, shown in the foreground. Behind is South Beach, San Francisco's newest residential neighborhood, which includes a marina and several low-rise apartment clusters.

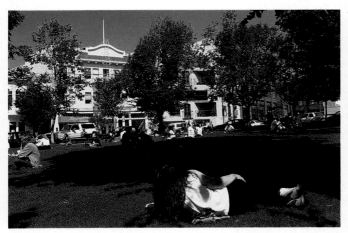

LEFT

South Park was San Francisco's most exclusive residential district until cable cars made the hills accessible; it was modeled after London's Berkeley Square. Galleries and restaurants are making it fashionable once more.

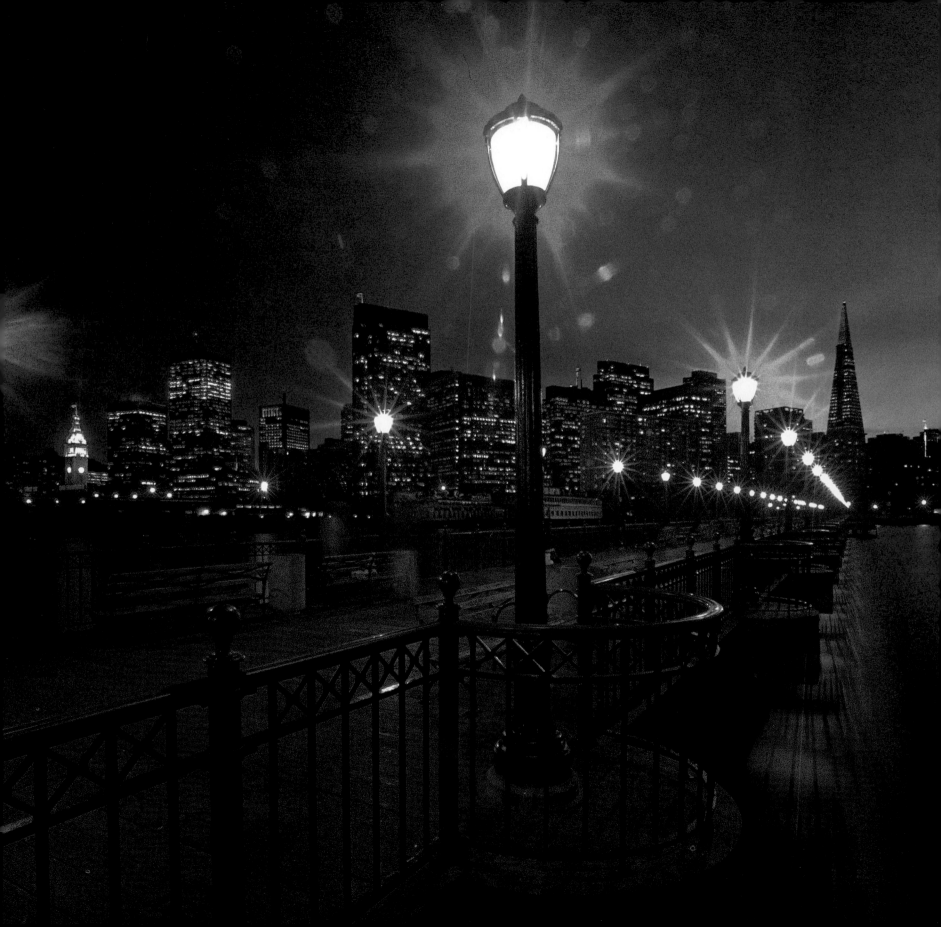

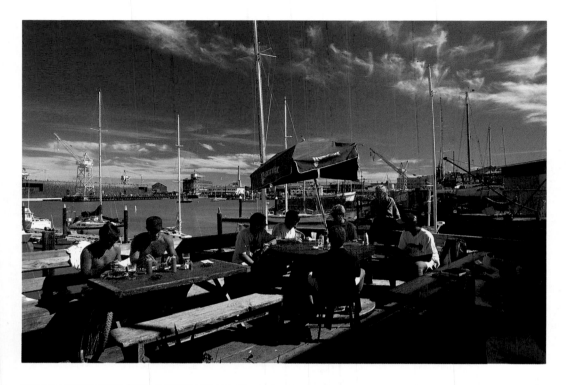

LEFT

Several restaurant/bars along the waterfront in an industrial corner of the city near China Basin are ideal for lunch when the fog has lifted. They're crowded and jolly, especially when the sun sparkles off the bay.

LEFT

Recently built, the pier at the beginning of Broadway looks like part of historic San Francisco, with graceful iron railings and old-fashioned lightposts. Walkers get a chance to see the city as it looked to the thousands of early travelers who arrived by ferry from points east.

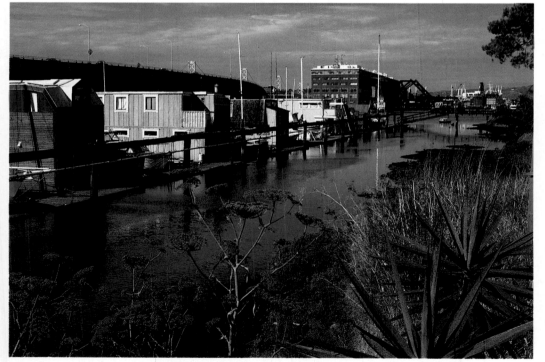

LEFT

Although neighboring Marin County has hundreds of houseboats, only a few San Franciscans are privileged to live on deck. Their homes are anchored at the China Basin inlet, a mini-neighborhood bounded by water.

FOLLOWING PAGES

The city of San Francisco owns 60,000-seat Candlestick Park, home of the Giants baseball team and the Forty-Niners football team. Most fans are familiar with the local climate and are liable to bring their hats and gloves to night games in July.

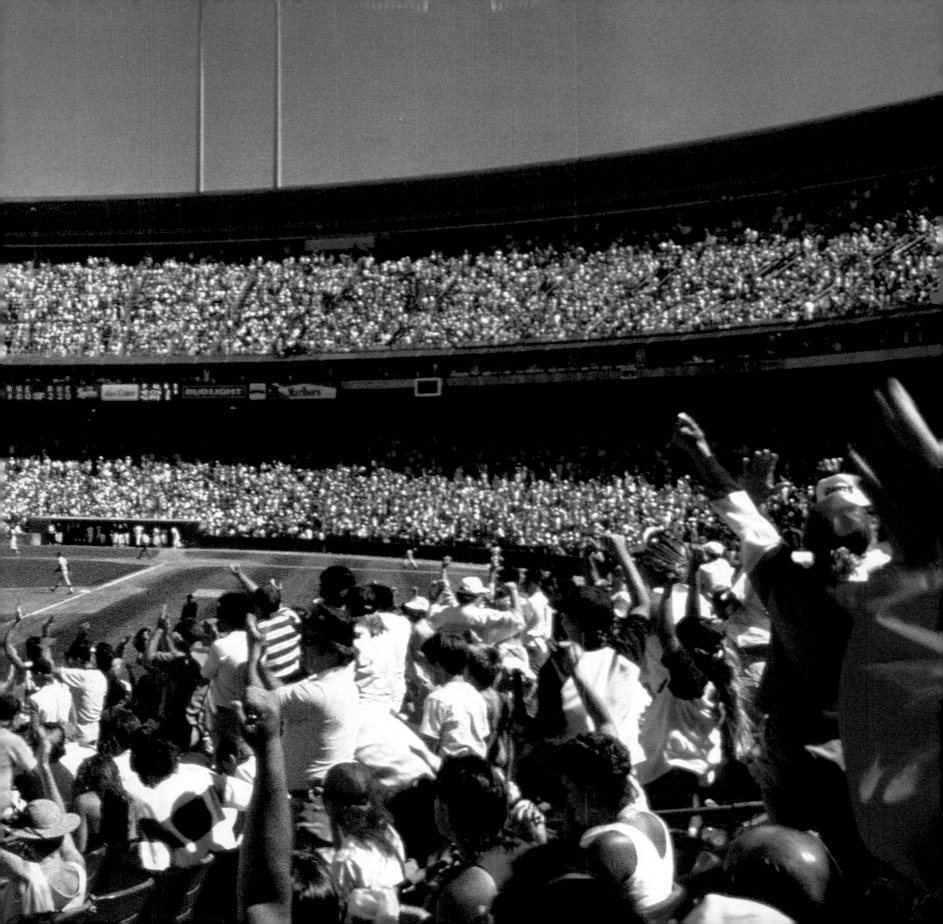

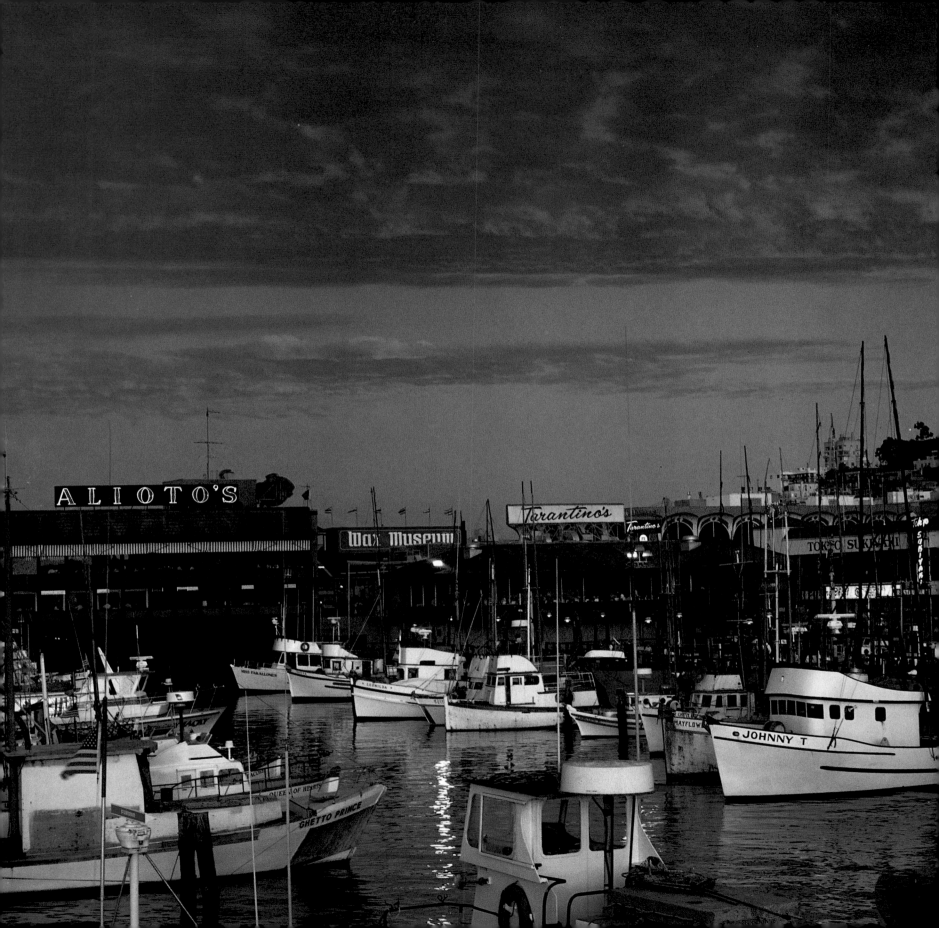

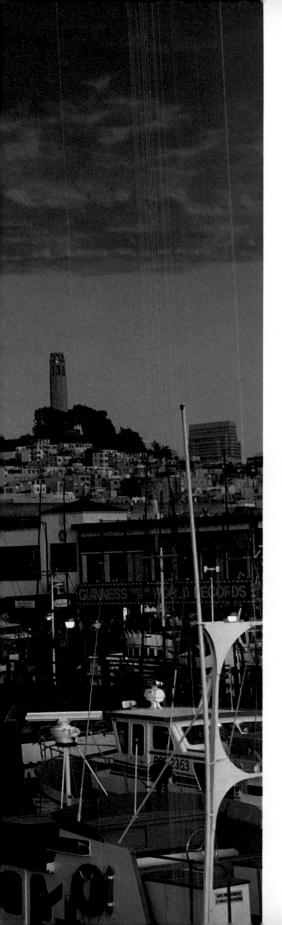

FISHERMAN'S WHARF

The first fishermen in San Francisco were Genoese Italians who came to California in the Gold Rush but failed to strike it rich. In 1900 they established what is now Fisherman's Wharf at the foot of Taylor Street as a pier and marketplace, where they could hawk the day's fresh catch at wharfside. Nearby residents thought this spectacle quaint and interesting, and the Wharf became a local attraction. Eventually, its appeal to sightseers overshadowed its function as a place of commerce. Although some fishing is still based in the area, nowadays it is mostly a focal point for visitors drawn to nearby amusements, shopping, cable cars, and Alcatraz. How commercially oriented is the Wharf? Less than 24 hours after the earthquake of 1989, its sidewalk vendors began selling "I Survived the Quake" T-shirts.

BELOW

The Hyde Street Pier at the edge of gracefully curving Aquatic Park used to be a port for ferries coming from Sausalito and Berkeley. Today, an array of historic ships is accessible from the pier, which is part of the National Maritime Museum.

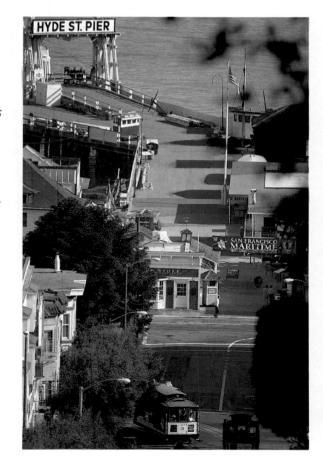

LEFT

The memory most visitors carry home from San Francisco is that of the Wharf, where business and pleasure mingle at the picturesque edge of the bay, a scenic backdrop unchanged by the years.

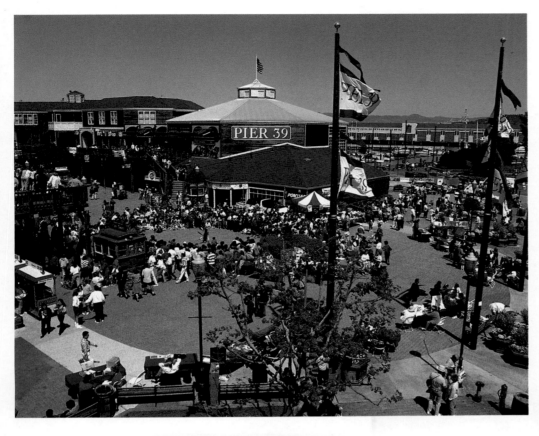

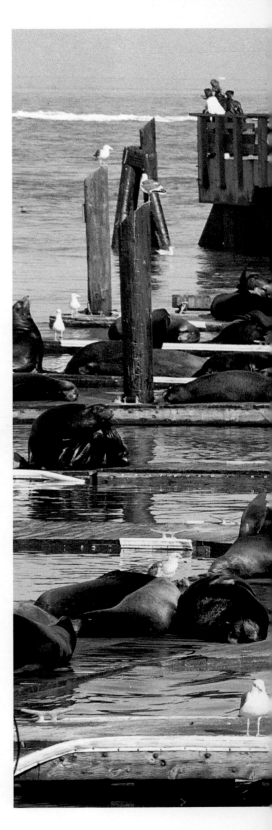

RIGHT

Stalls along Taylor and Jefferson streets—many of them owned by the descendants of Italian Americans who fished the bay—offer "cracked crab," Dungeness crab trapped just outside the Golden Gate, king and silver salmon, sea bass, cod, sand dabs, sole, mackerel, perch, halibut, abalone, and sole.

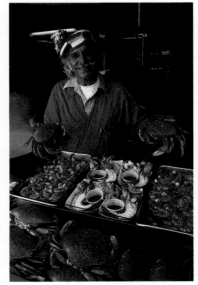

ABOVE

Pier 39, located at the northern most point of San Francisco, is a shopping, amusement, dining, and entertainment complex built in 1978. The modern structure uses lumber recycled from the 1905 pier that once stood on the site.

RIGHT

California sea lions, once reliably visible only on Ocean Beach's Seal Rock, have gone downtown. They hang around Pier 39, basking in the sunlight and posing for animal lovers' snapshots.

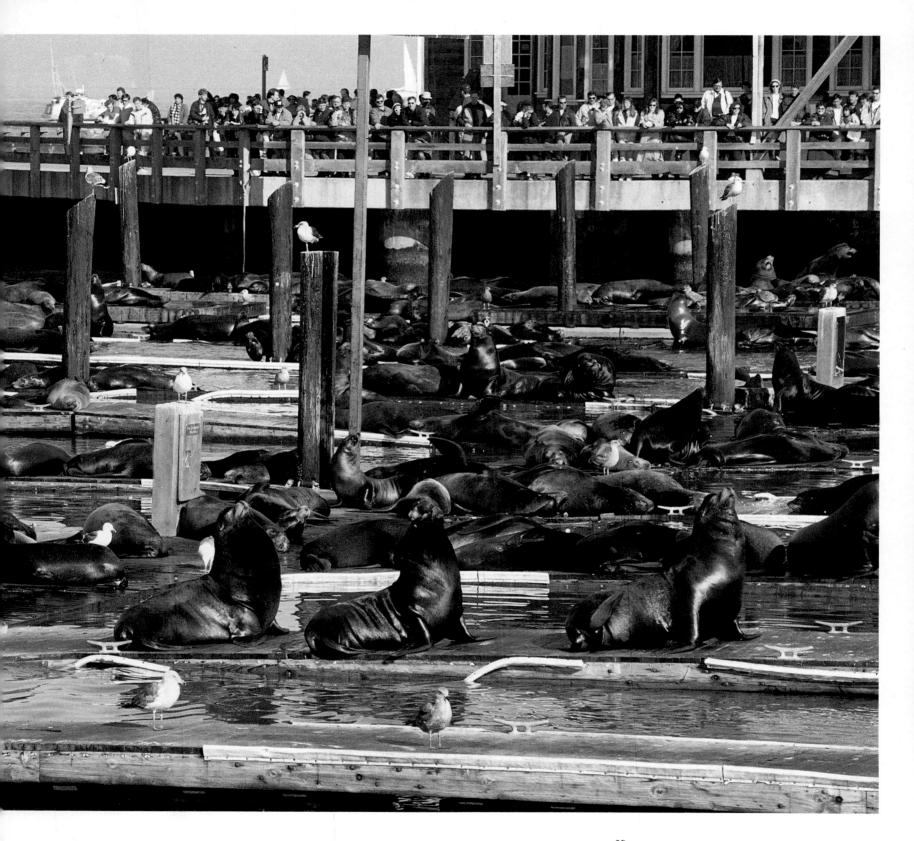

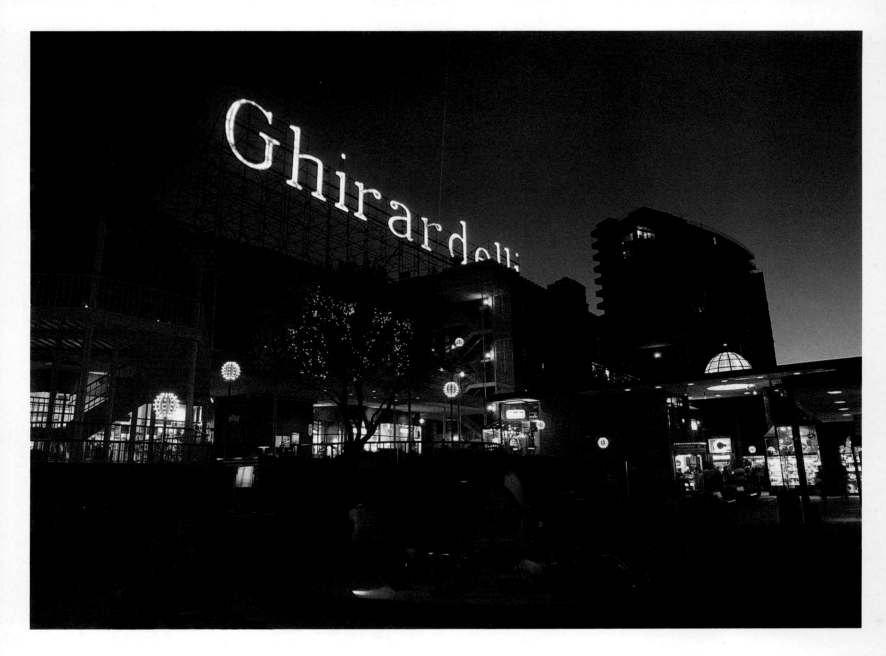

Domenico Ghirardelli
opened a chocolate shop in
San Francisco in 1852. This
factory has been turned
into an international bazaar
of shops and restaurants
encircling a fountain and a
flower-filled courtyard.

The *C. A. Thayer*, a wooden-hulled, three-masted schooner,
was built in 1895 to bring lumber to the boomtown of
San Francisco from the Pacific Northwest. The *Thayer*
was the last wind-powered commercial ship in use on the
West Coast until it was retired in 1950.

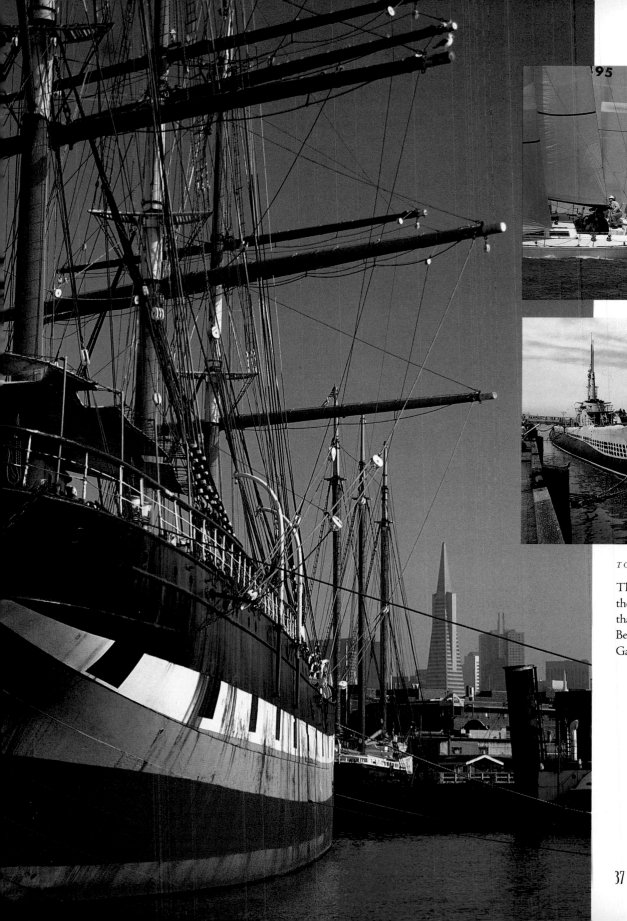

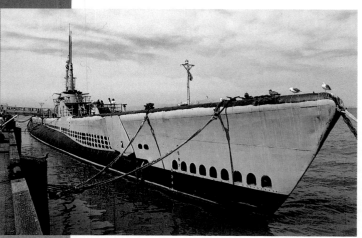

TOP

The brisk bay winds fill the sails of racing boats that dot the bay from Berkeley to the Golden Gate on weekends.

ABOVE

The USS *Pampanito*, a World War II submarine, is anchored near Fisherman's Wharf at Pier 45.

ALCATRAZ

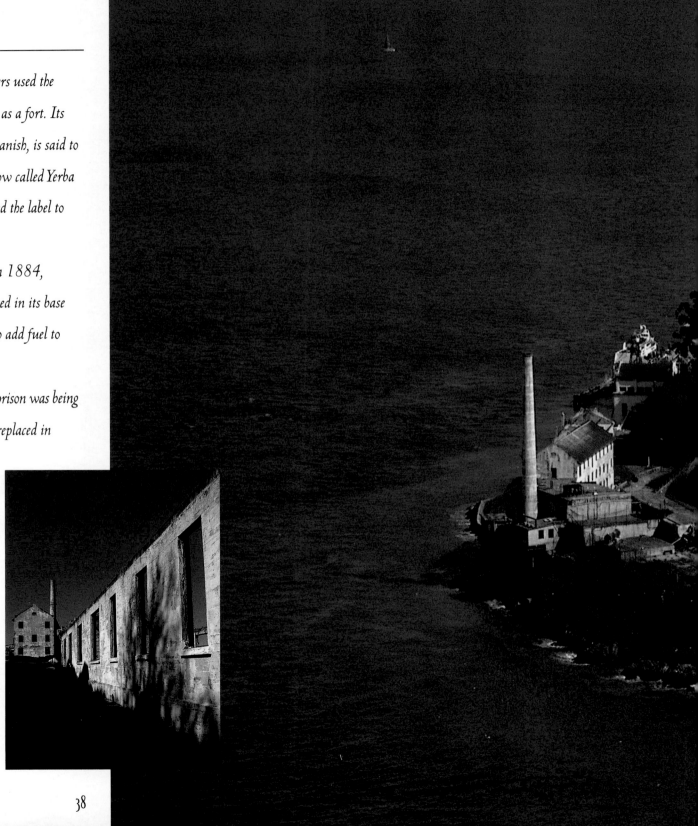

S an Francisco's Spanish settlers used the 12-acre island of Alcatraz as a fort. Its name, which means pelican in Spanish, is said to have been intended for the island now called Yerba Buena; a careless mapmaker affixed the label to the wrong body of land.

The Alcatraz lighthouse, built in 1884, was maintained by keepers who lived in its base and climbed to its peak every day to add fuel to the lamps.

The structure was hidden as the prison was being built in 1907; the lighthouse was replaced in 1909 by a taller tower that used an electric light. Its rotating beam is visible every night from the northern edge of the city.

Many guidebooks aren't kind to Alcatraz—visitors "can do better things with their time than spend half a day visiting a ruined prison," reads a typical entry—but even romantics aren't immune to its eerie majesty. The rugged beauty of the island's rocks jutting from the bay is strikingly juxtaposed with the dramatic skyline looming across the water.

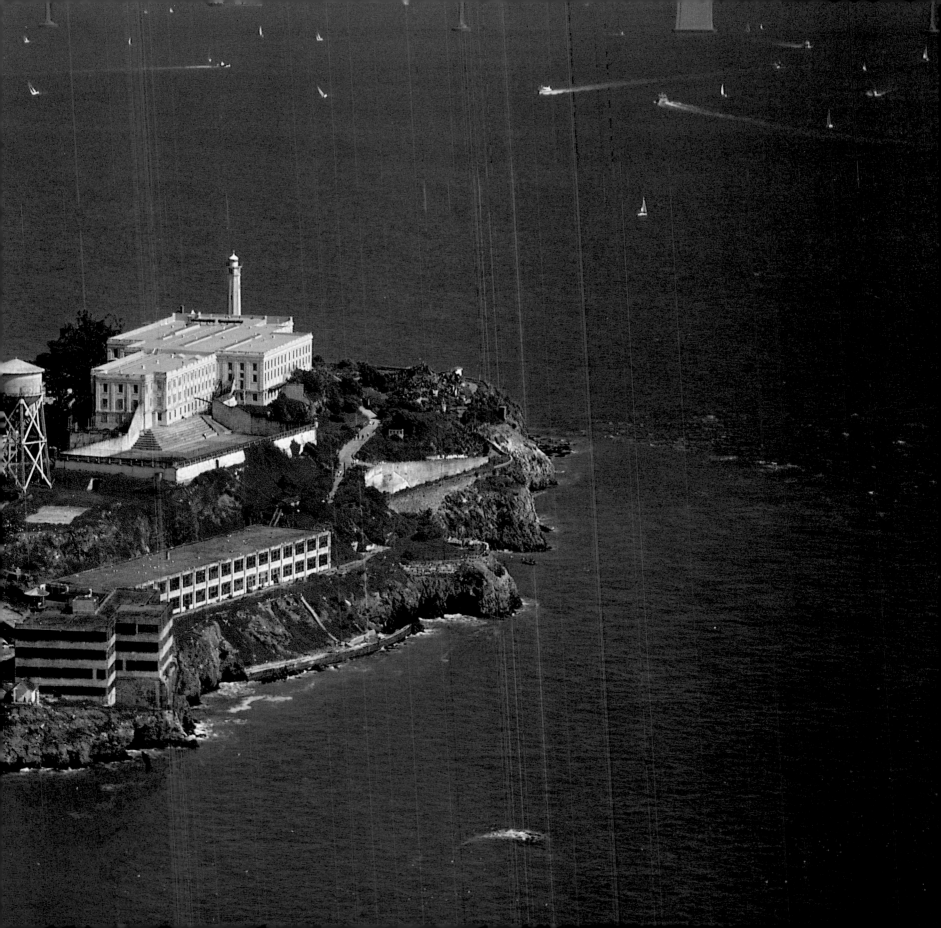

CABLE CARS

A newspaper reporter visiting San Francisco from India in 1889 couldn't contain his amazement at the cable cars that carried commuters around the city. "They take no count of rise or fall," wrote Rudyard Kipling of the 16-year-old cars. "They turn corners almost at right angles, cross other lines, and for aught I know, may run up the sides of houses."

The cable car system was invented by Andrew Hallidie, a manufacturer of wire rope whose imagination had been stirred by the sight of a team of five horses attempting to pull a heavy wagon up the steep hill of Jackson Street. When one of the horses slipped and fell, the whole wagon and team were dragged down the hill together.

Four years after the accident, Hallidie designed a system of subsurface cables, powered by a central boiler, to which moving cars could be attached. At the height of the system's use, there were eight lines in operation over 112 miles of cable car track.

LEFT

The California Street line carried wealthy financiers from their offices on Montgomery Street to their residences atop Nob Hill. Before the cable cars went into operation, San Francisco's wealthiest citizens lived in level neighborhoods such as South Park.

RIGHT

Nearing its terminal turnaround, a Powell-Hyde cable car moves down the north flank of Russian Hill, which has the steepest slope (20.67 percent) of any in the three existing lines. Near its crest are the Alice Marble Tennis Courts, named after one of the first women professional players. The Powell-Hyde line was the last built of the eight that once traversed the city.

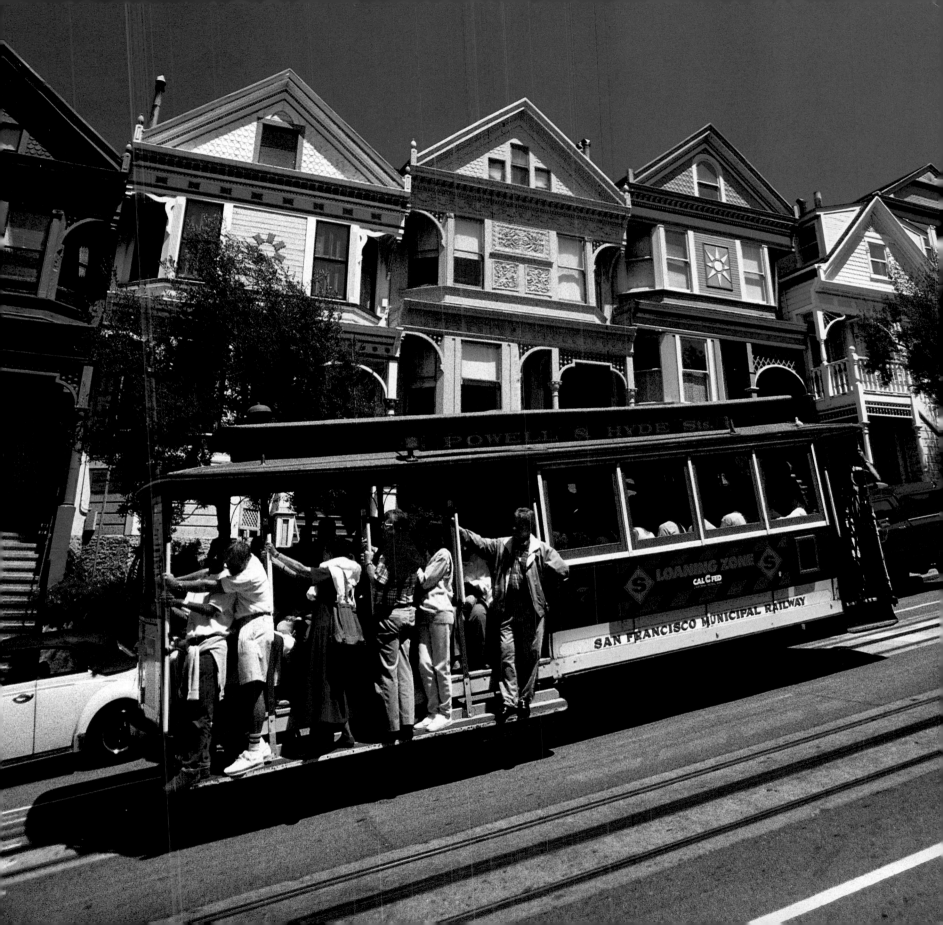

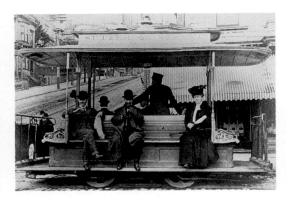

Cable Car Museum

The machinery that propels the cables for the three existing cable car lines is housed in the cable car barn on Nob Hill, which is also home to a museum of cable car history.

At various times over the years, "progressives" have talked about replacing the cars with buses or trolleys. In 1947, the city experimented with vehicles that the practical-minded deemed more efficient, and closed down several cable car lines.

None, however, worked as reliably (or charmingly) as the cable cars.

Between 1981 and 1984, the system was shut down for overhauling. The downtown areas crossed by the lines were eerily quiet without the clatter of the cables moving underground and the bells clanging as the cars approached intersections.

When the cars came back, San Franciscans cheered the resuscitation of their streets' heartbeat.

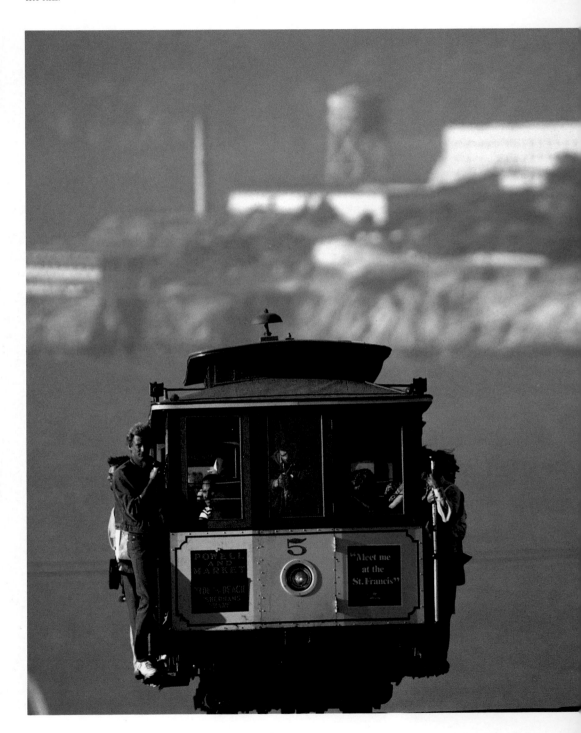

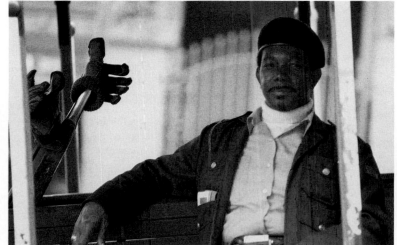

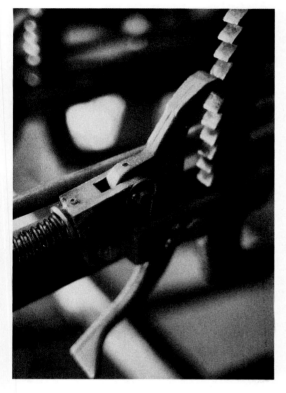

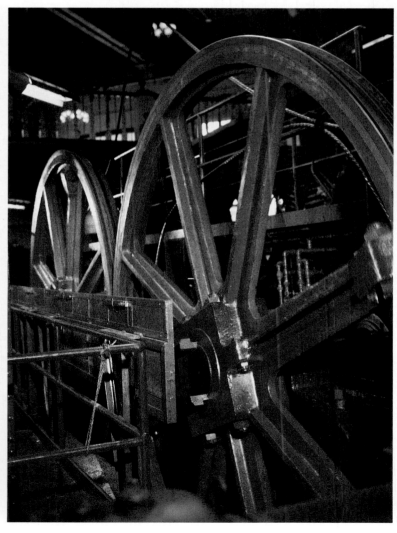

CENTER, TOP

Each car is operated by a conductor and a gripman, who uses a lever to attach the car to the moving cable. The gripman uses the lever to clamp the grip to the cable, which drags the car along at a constant speed of nine miles per hour.

ABOVE

A brake at the back of the car stops the cable car with a device that presses wooden blocks against the rails.

LEFT

The cable car barn houses a set of wheels for each of the three remaining lines, around which the moving cable is threaded.

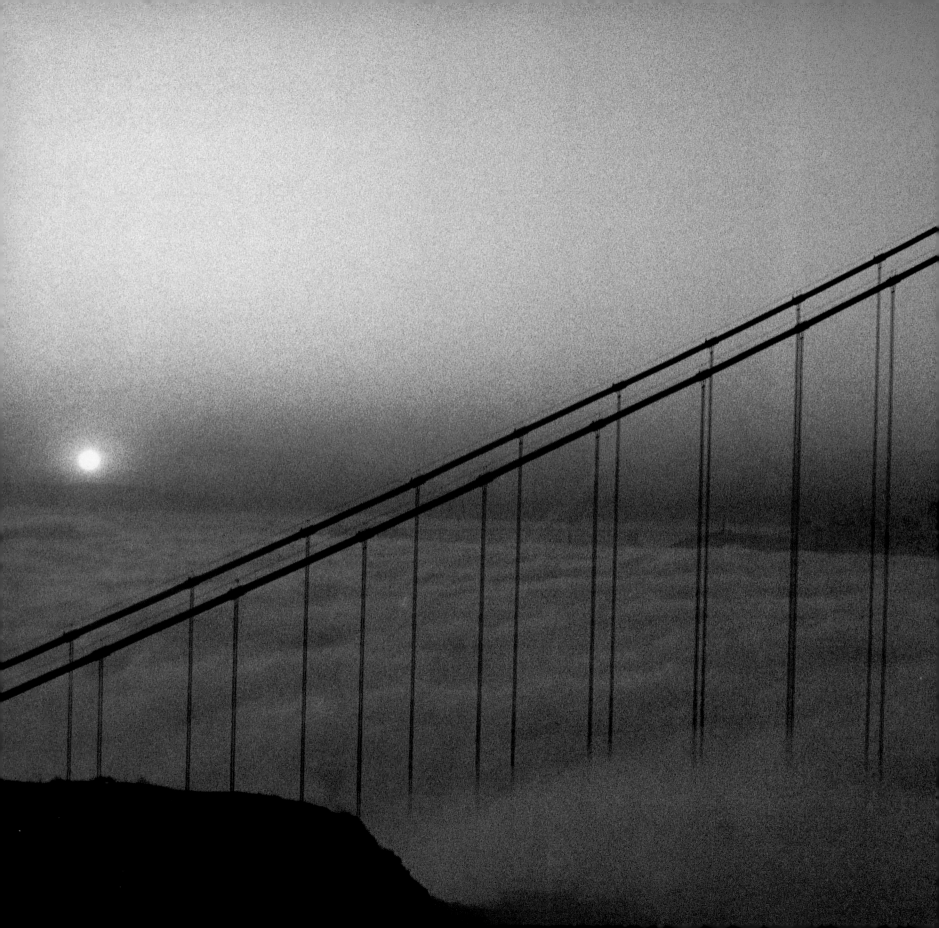

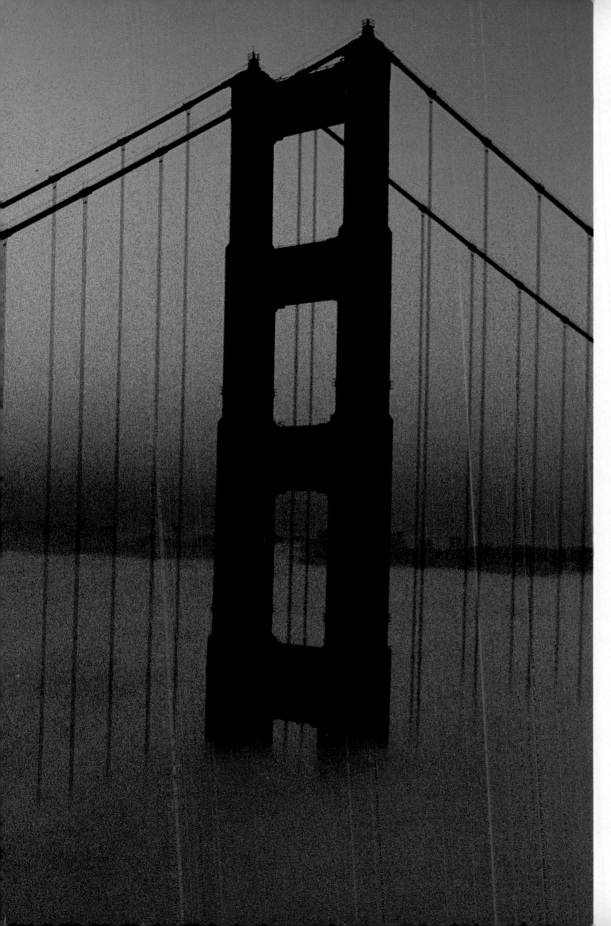

BRIDGES

*T*he Bay Bridge, completed in 1936 as one of many Depression-era projects that created thousands of jobs for Bay Area workers, stretches eight and one-half miles, dipping and twisting from San Francisco past Yerba Buena and Treasure islands to Oakland. This bridge is a workhorse, but its glamorous sibling, the Golden Gate Bridge, captures the romance of the Bay Area. Completed in 1937, the Golden Gate Bridge was an immediately recognized wonder, the longest single-span bridge on the planet. Its sweeping arches form San Francisco's most enduring symbol, a structure that has, like the city itself, survived unpredictable seismic instability and withstood buffeting winds and traffic.

Sunrise from the Golden Gate Bridge, looking south from Marin County toward Telegraph Hill and downtown San Francisco.

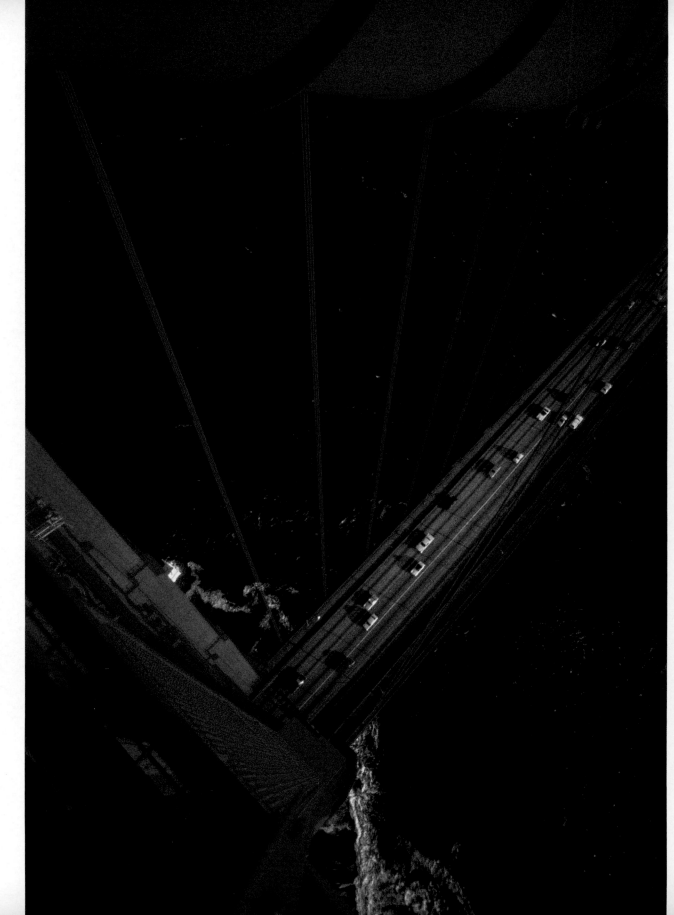

The roadway as seen
from one of the Golden
Gate Bridge's two pilings.
Pilings and cables are
painted international
orange, a distinctive terra
cotta color that was
developed as the struc-
ture's signature color by
engineer Joseph Strauss
and consulting architect
Irving Morrow.

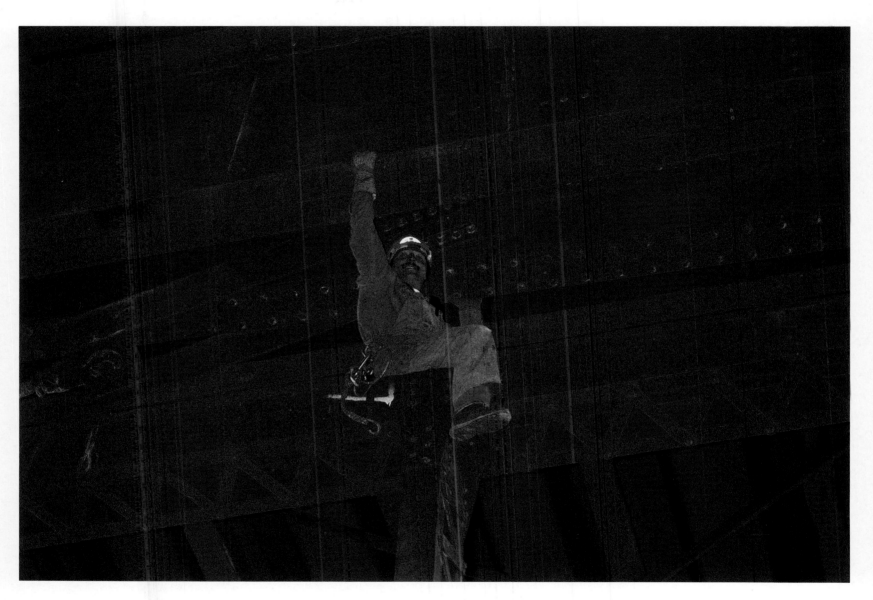

An iron worker tends to the underside of the bridge.
Morrow insisted that standard X-shaped braces be put
below the roadbed rather than on top to simplify the
silhouette of the structure against the sky.

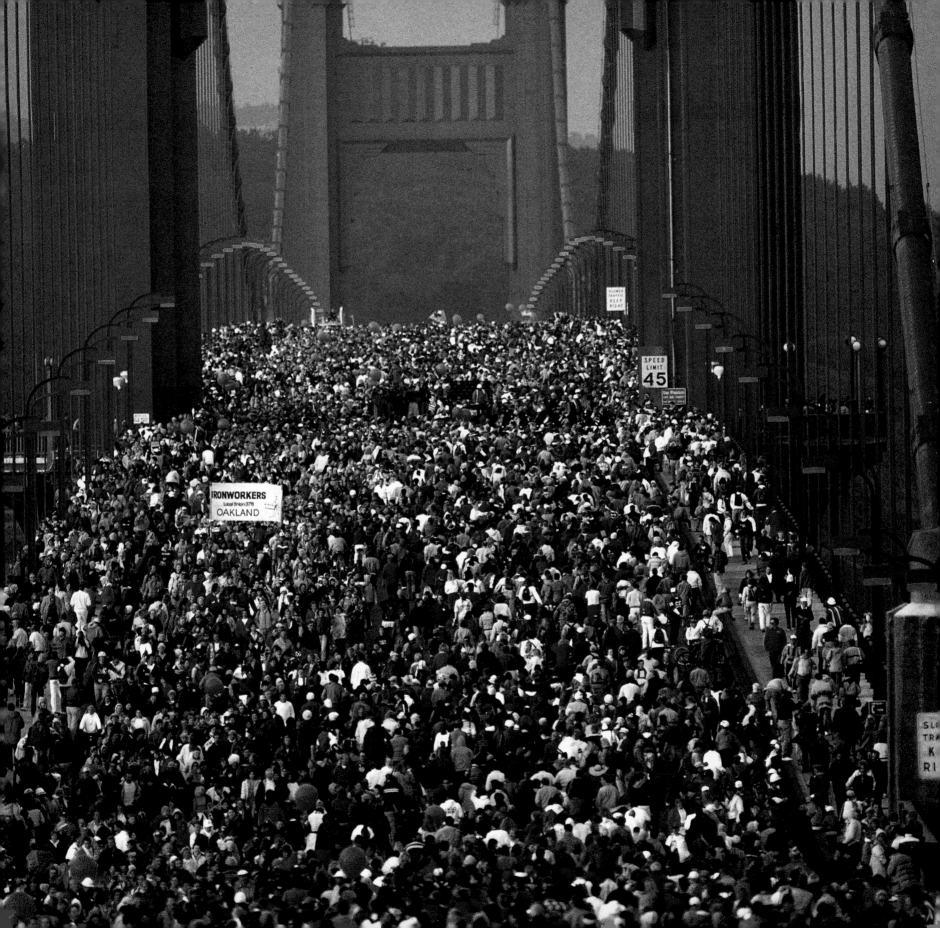

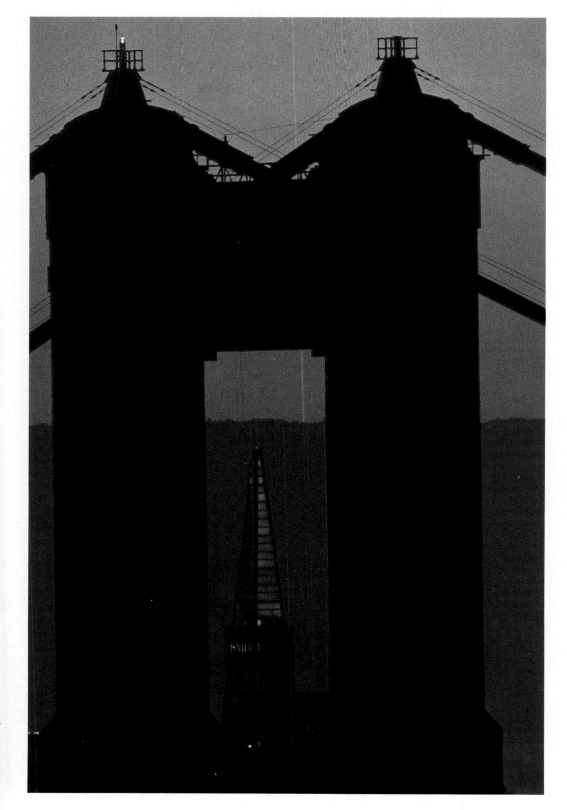

LEFT

The Transamerica Pyramid in downtown is framed by the structure of one of the Golden Gate Bridge's two pilings.

FOLLOWING PAGES

While the rest of the country is baking in sunshine, the summer months are often windy and foggy in San Francisco. Sailors make good use of their foul-weather gear, and vacationers make good use of their sweaters.

LEFT

The weight of 800,000 strollers flattened the road deck during the Golden Gate Bridge's 50th anniversary celebration, but the structure endured. Opening day festivities in 1937 had attracted 200,000.

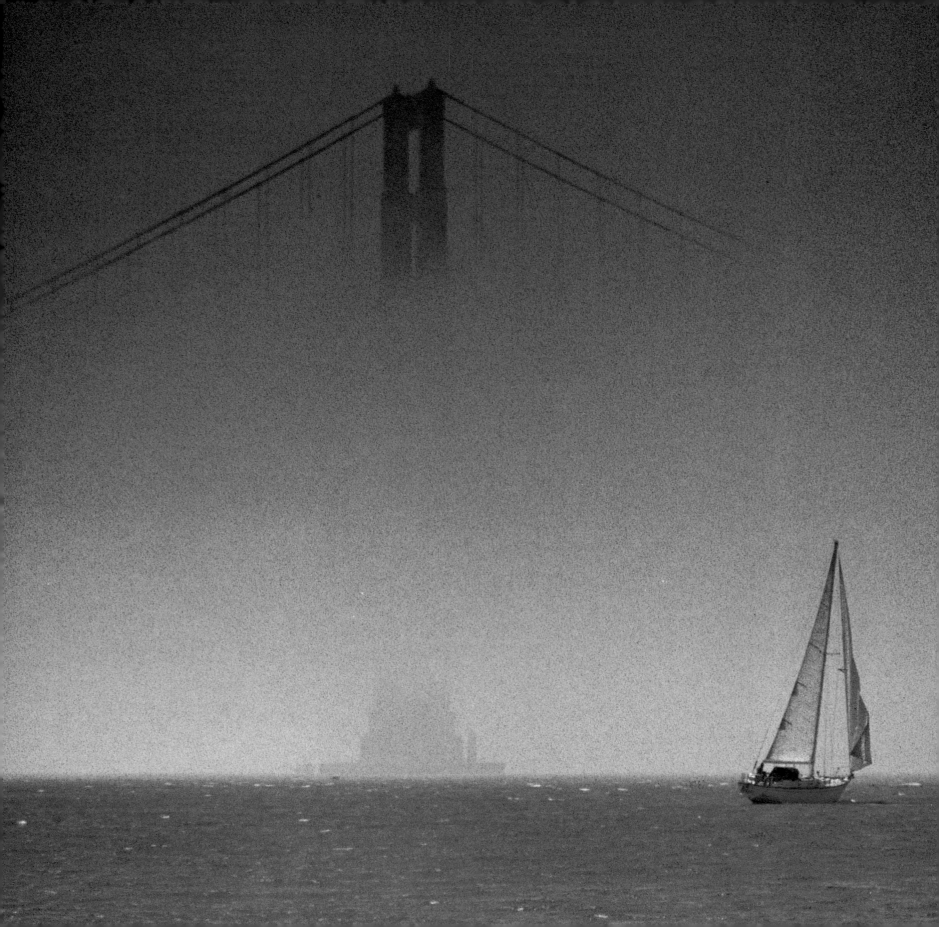

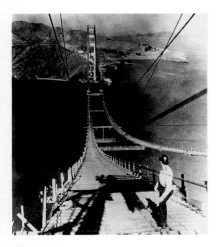

Under Construction

Work started on the Golden Gate Bridge on January 5, 1933. The project was planned by officials in six surrounding counties, who had agreed five years earlier to create the Golden Gate Bridge District, which would raise money, monitor the construction, and oversee the administration of the completed span.

Engineer Joseph Strauss, a visionary who once planned to build a span across the Bering Strait, is credited for the design of the Golden Gate Bridge, but it is said that his aide, Charles Alton Ellis, made the calculations that enabled the structure to be built. Strauss died in 1938, a year after the bridge opened. Sentimental friends believed that his death was quickened by the negativity of pessimists who believed that his last project was an impossibility.

The bridge is more than a mile long; at its central point, the roadway is 220 feet above the water; the distance between its two piers is about 4,200 feet. Each of the two cables from which the bridge is suspended are 36.5 inches in diameter and 7,659 feet long. Each cable contains 27,572 parallel wires; if unwound, the wires would wrap the Earth's equator three times.

To withstand winds and earthquakes, the bridge was designed to be flexible. Engineers estimated that if it were to be hit with a 100-mile-per-hour wind, the roadway of the bridge could swing 27 feet.

What the engineers didn't plan for was the 50th anniversary celebration of the Golden Gate Bridge, when the span was closed to traffic and thousands of pedestrians converged to take a ceremonial stroll at dawn (see page 50). The crowd was so dense that the arch of the roadway flattened out as bridge district officials looked on in disbelief. They needn't have worried. The Golden Gate Bridge stood its ground.

(see page 50)

RIGHT

Just west of the Golden Gate, on the San Francisco side, Baker Beach is a favorite spot for fishing, strolling along the shore, and, at its eastern end, nude sunbathing.

BELOW

Under the bridge is the natural Golden Gate, an underwater cleft in the Coastal Mountain Range that forms a valley linking the Pacific Ocean to the San Francisco Bay.

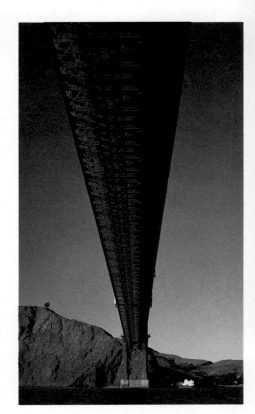

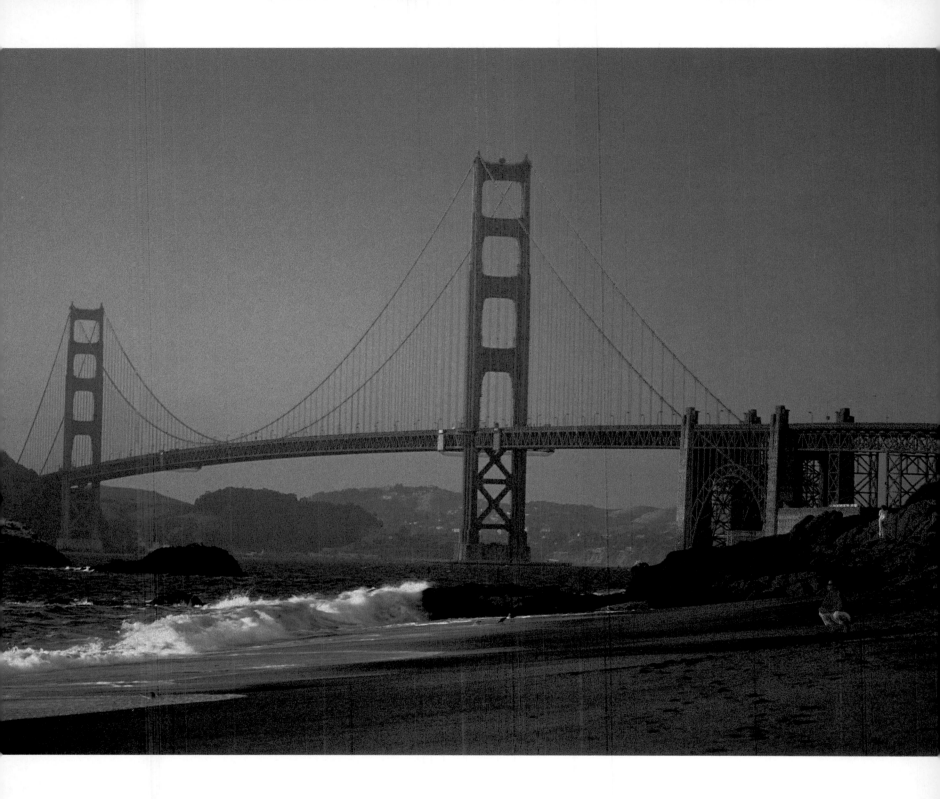

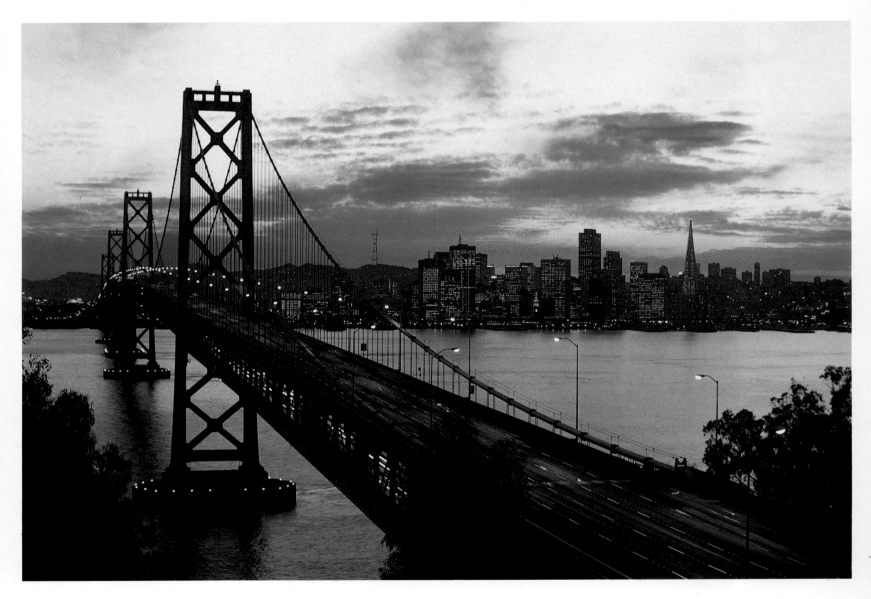

The Bay Bridge, completed in 1936, was the most expensive single structure built to that date. It carries more cars per day—about a quarter-million—than does the Golden Gate Bridge, and is visible from most places in downtown San Francisco. The bridge passes over Treasure and Yerba Buena islands, both of which house military facilities.

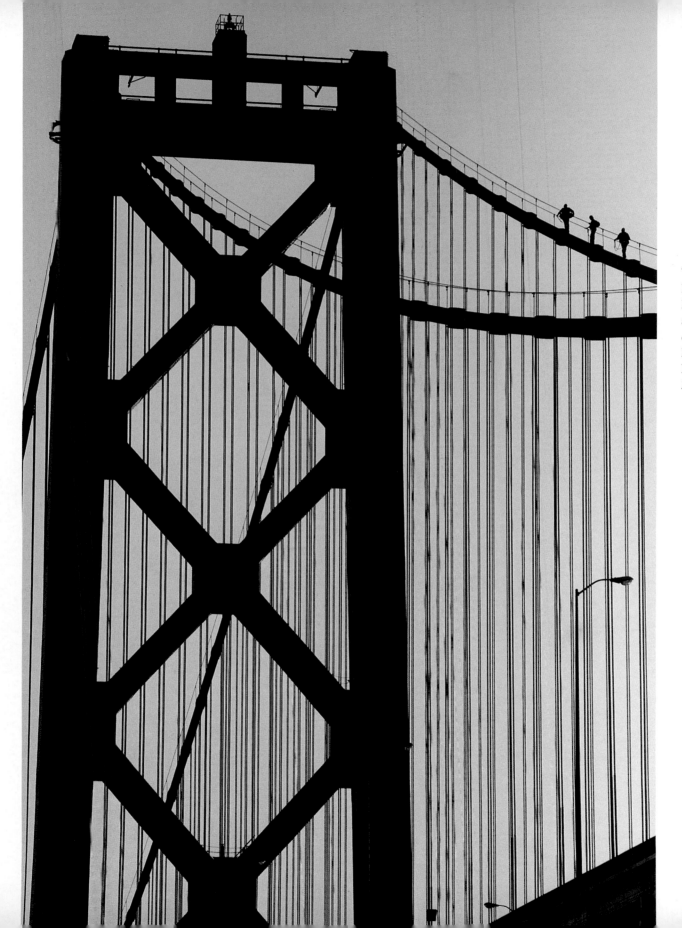

The structure of the Bay Bridge is taller than the largest pyramid in Egypt and contains more concrete than New York's Empire State Building. Its deepest pier extends 242 feet below water.

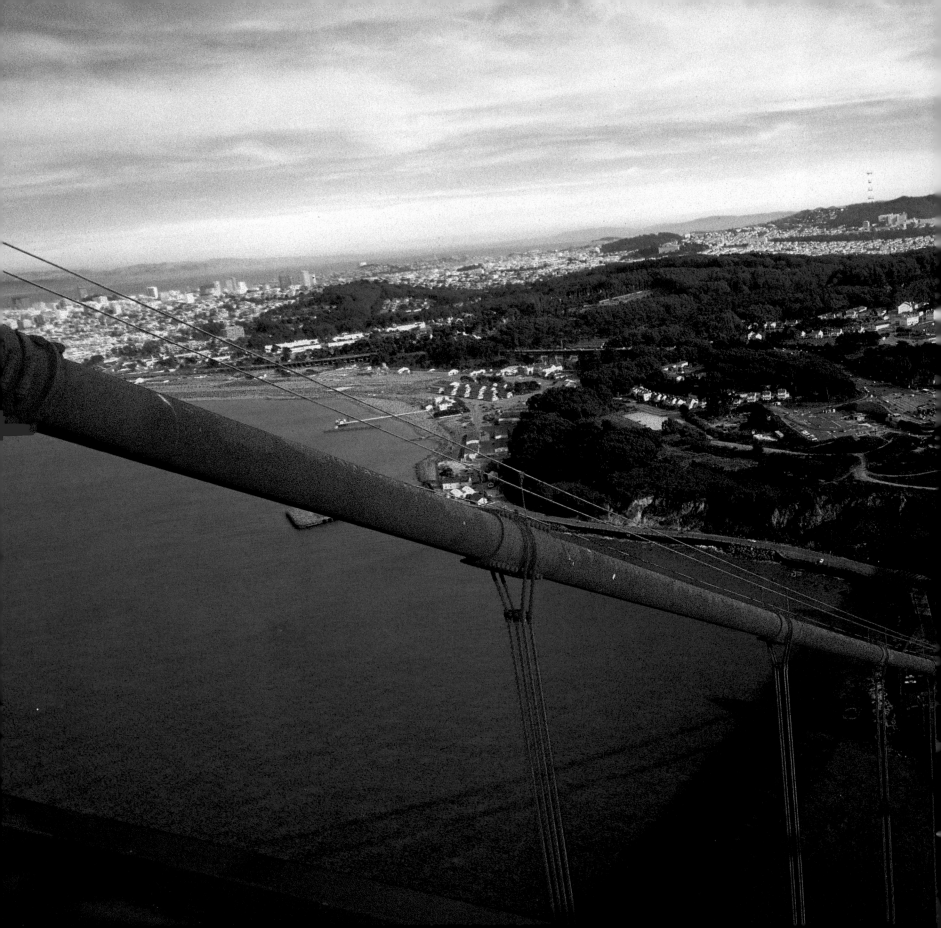

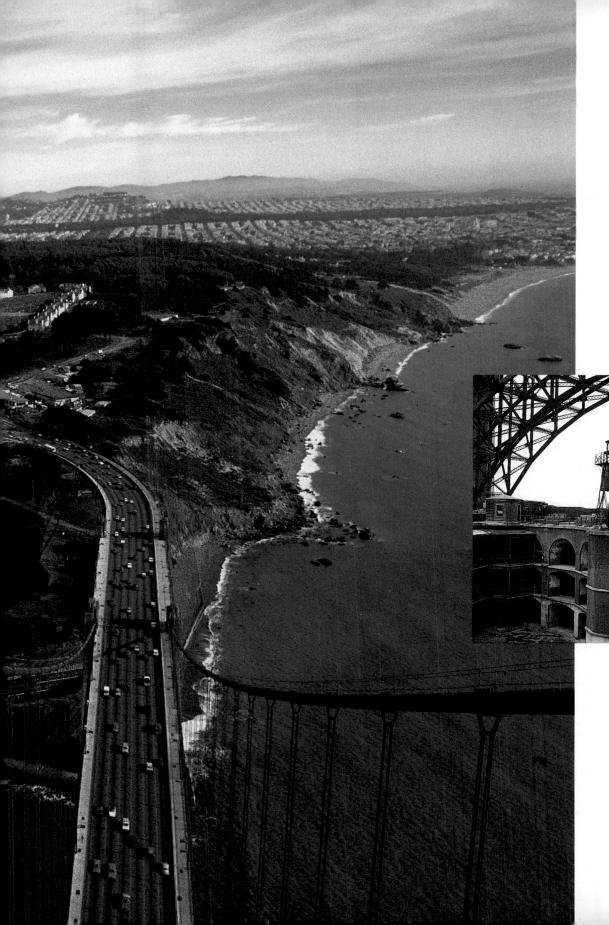

THE PRESIDIO

The Presidio, which became headquarters of the Sixth Army in 1947, occupies the northwest corner of the city. The verdant valleys of the 1,500-acre tract are thick with 60,000 trees, including cypresses, madrones, redwoods, acacias, and eucalyptus. The fort was established in 1776 by the Spaniards and was taken by the United States in 1846. In the fall of 1994, most of the military property became part of the Golden Gate National Recreation Area. The addition of the Presidio to this federal park created a link connecting the park's southern and northern portions, which stretch along the Pacific from south of the city to Marin County.

LEFT AND INSET

Fort Point, located at the southern base of the Golden Gate Bridge, was built during the Civil War. It is the oldest brick fort west of the Mississippi River.

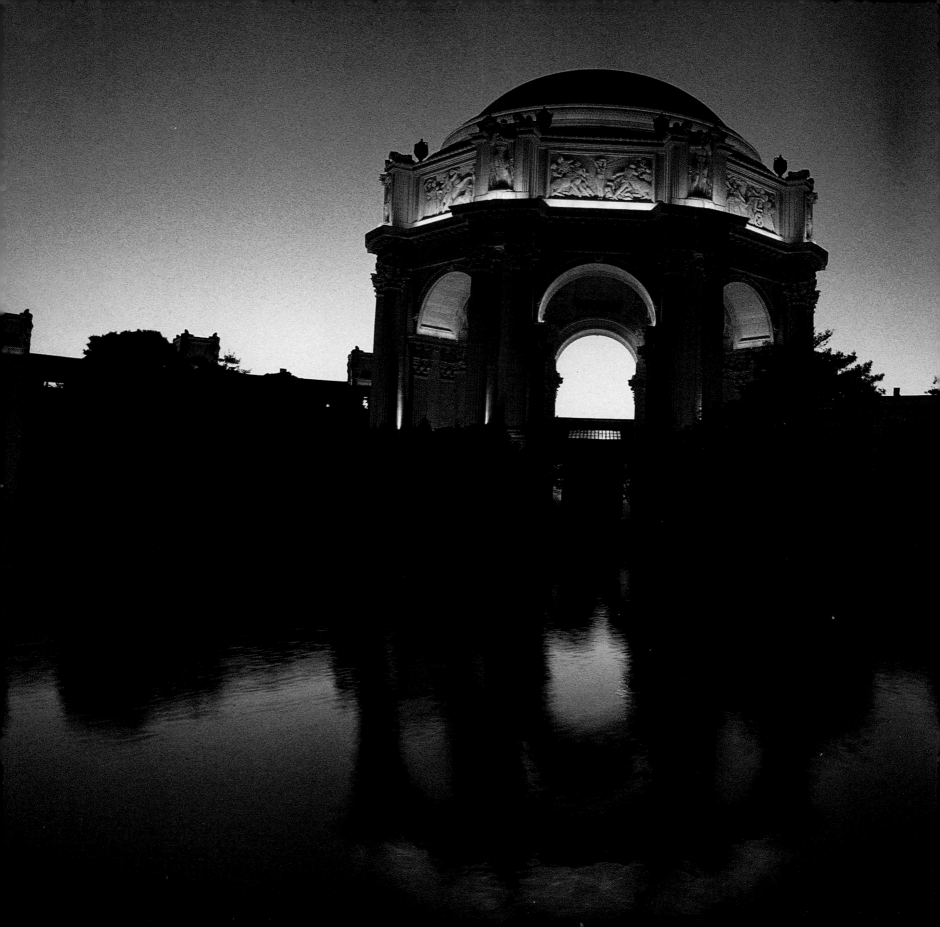

Bernard Maybeck's much-admired Palace of Fine Arts, which has been described as a "Beaux Arts hallucination," is the site of many splendid events. Walter Johnson, a philanthropist who lived across the street, spear-headed the campaign to preserve the building.

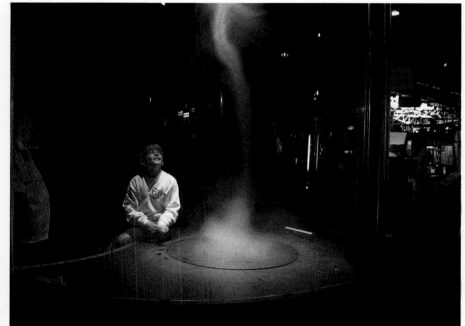

ABOVE

The Exploratorium, a world-famous hands-on museum of science and technology, is in the main exhibition hall of the Palace, where sculpture and paintings were displayed during the Panama-Pacific International Exposition in 1915.

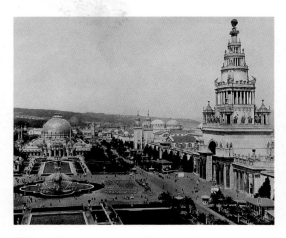

The Panama-Pacific International Exposition

In August 1914, the first ship to sail from the Atlantic to the Pacific without going around Cape Horn made its way through the brand-new Panama Canal. The steaming distance between New York and San Francisco was thus shortened by 7,873 miles, more than enough reason for an official celebration.

Chief architect George Kelman's eight central exhibition halls included the Palace of Machinery, an homage to industrialization, and the Palace of Fine Arts, an homage to the arts. Among the adjacent structures were a Tower of Jewels studded with bits of multicolored glass from Bohemia, a Horticulture Palace, gardens designed by Golden Gate Park designer John McLaren, a Festival Hall that seated 3,500, and an amusement park that had carousels, dioramas, and models of parts of the Panama canal.

The fair cost $15 million to build and opened exactly on time, with 150,000 visitors waiting at the gate and a parade that stretched two and one-half miles from Van Ness and Broadway. It was a huge success, remaining open for 288 days, generating enough profits to pay for the building of the Civic Auditorium (still in use), and reaping a million-dollar surplus.

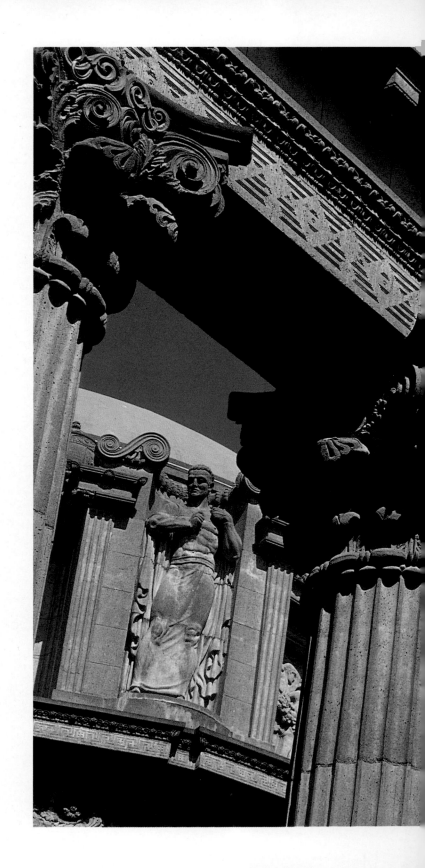

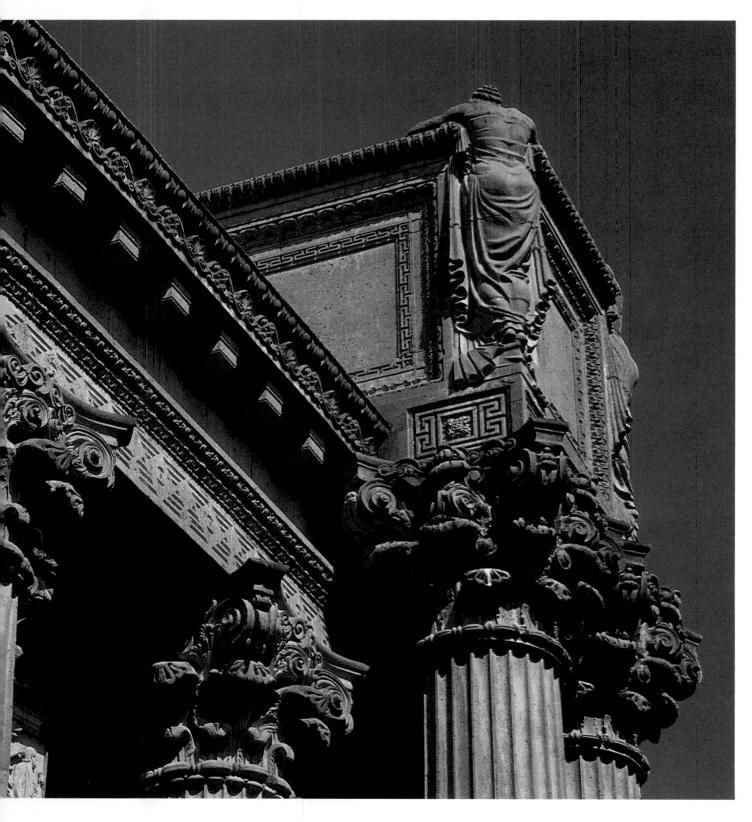

A ring of colonnades
surrounds the lagoon
next to the Palace of
Fine Arts, each of which
is topped by a square
stone container with
nymphs at the corners.
Original plans called for
the nymphs, mourning
the prospect of life
without art, to be scatter-
ing imaginary blossoms
into plants that would
be set in each container.

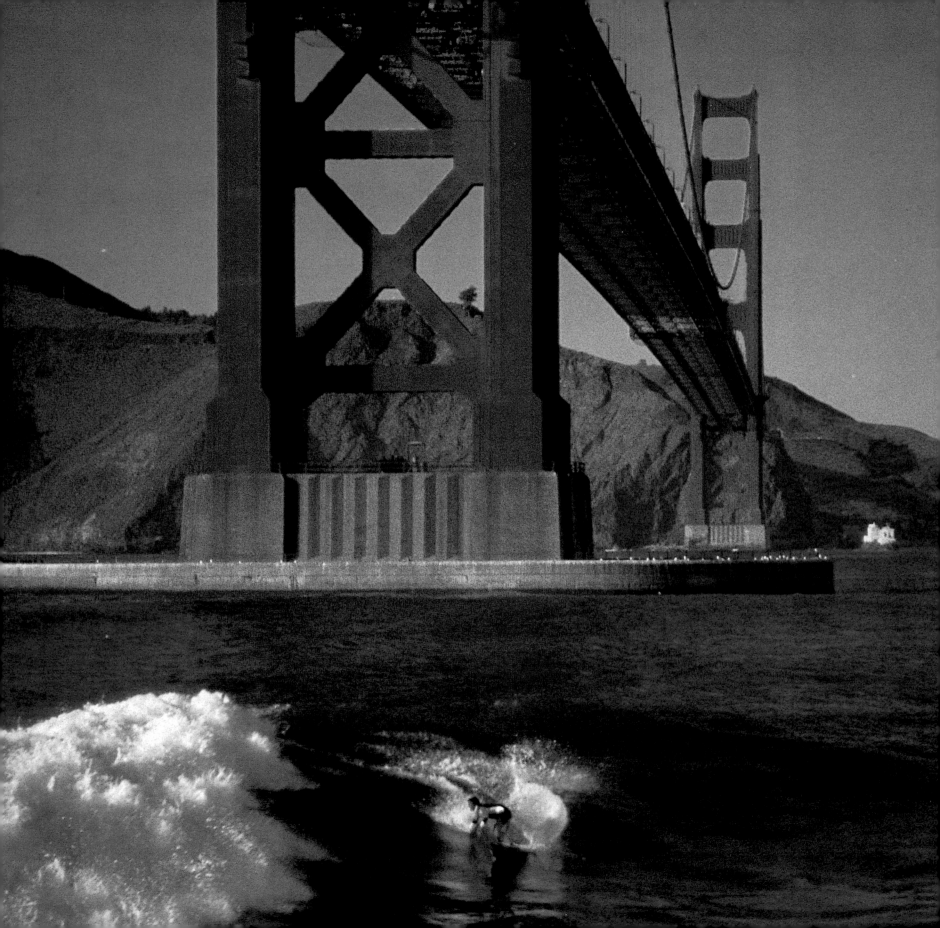

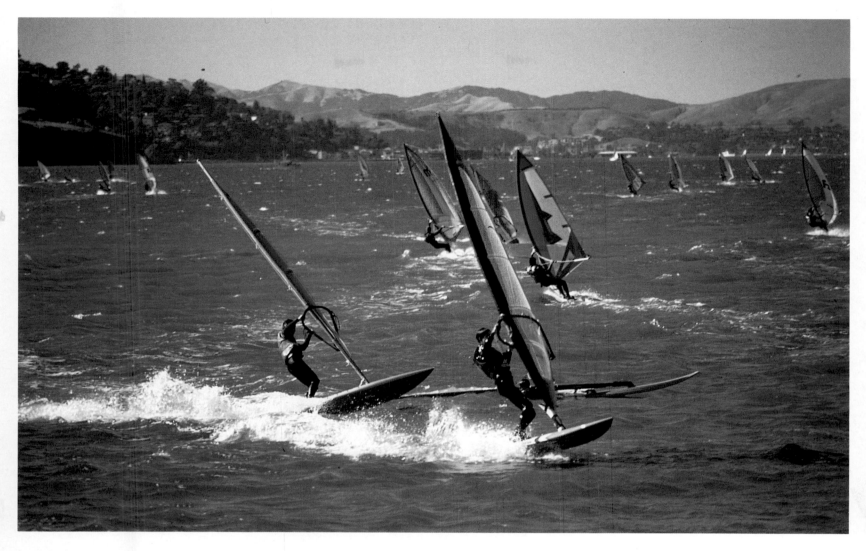

LEFT AND ABOVE

In the cold waters between the Golden Gate Bridge and Alcatraz, where the bay and the Pacific tangle and swirl, surfers, windsurfers and sailors test their skills against the elements.

RIGHT

The run, walk, or meander alongside the water from the Marina Green to Fort Point and back is a scenic four miles.

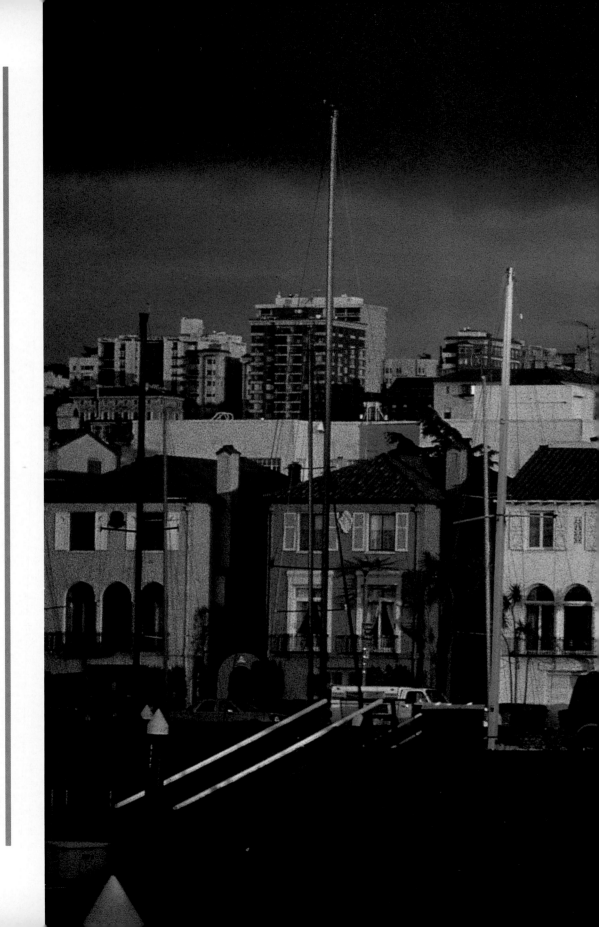

Quake of '89

In late afternoon on October 17, 1989, Americans from Bangor to San Diego, from Seattle to Key West switched on their television sets and looked at San Francisco. The third game of baseball's World Series — in which the San Francisco Giants were pitted against the Oakland A's — was about to begin. At Candlestick Park, for once windless and hot, a crowd of 60,000 was gathering.

Then, at 5:04 P.M., the event San Franciscans had dreaded since 1906 occurred. A major earthquake, 7.1 on the Richter scale, collapsed buildings, freeways, and a section of the Bay Bridge; knocked out electrical and gas lines; and, as had the quake of '06, caused fires and devastation.

Ninety-five percent of the city remained unharmed, especially downtown areas where modern office towers had been built in accordance with earthquake safety standards. The Marina District, where most homes had been built on sand and landfill, was hardest hit, its buildings tumbled, its streets cracked, its survivors threatened by conflagration.

In other areas of the city, long-forgotten topographical features — underground streams, subsoil rocks — were reflected in the patterns of destruction.

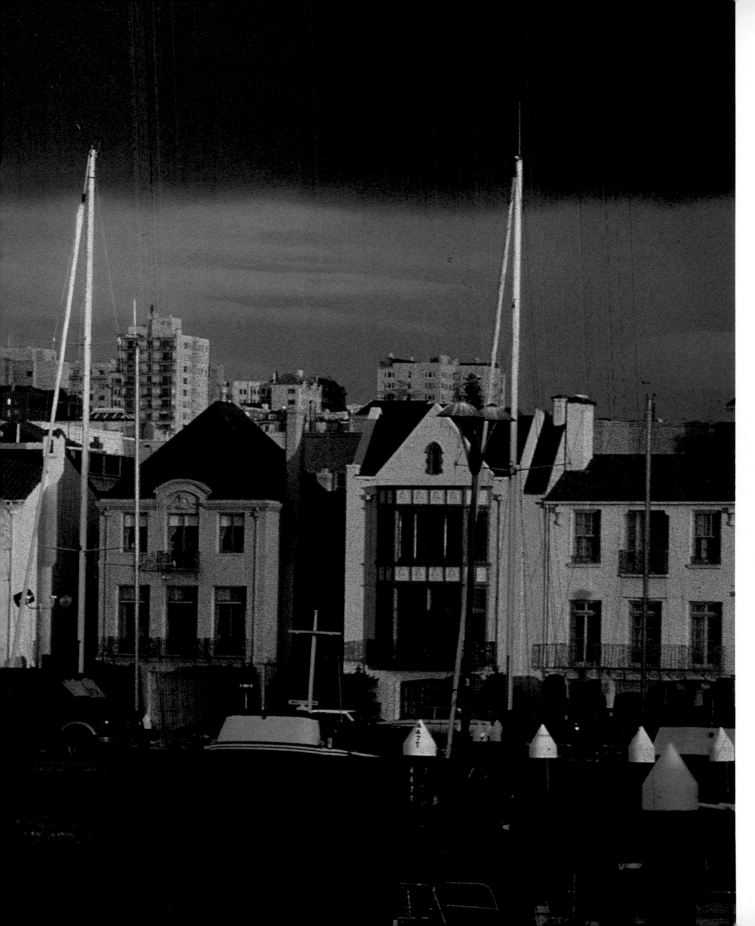

The gleaming stucco exteriors of houses in the Marina District, many of which were built in the 1920s, give the area a Mediterranean look. Nearby Chestnut Street has the bustle and charm of an Italian town, and the ornate Vedanta Temple at Webster and Filbert, completed in 1905, is a Victorian curiosity of curves and geegaws.

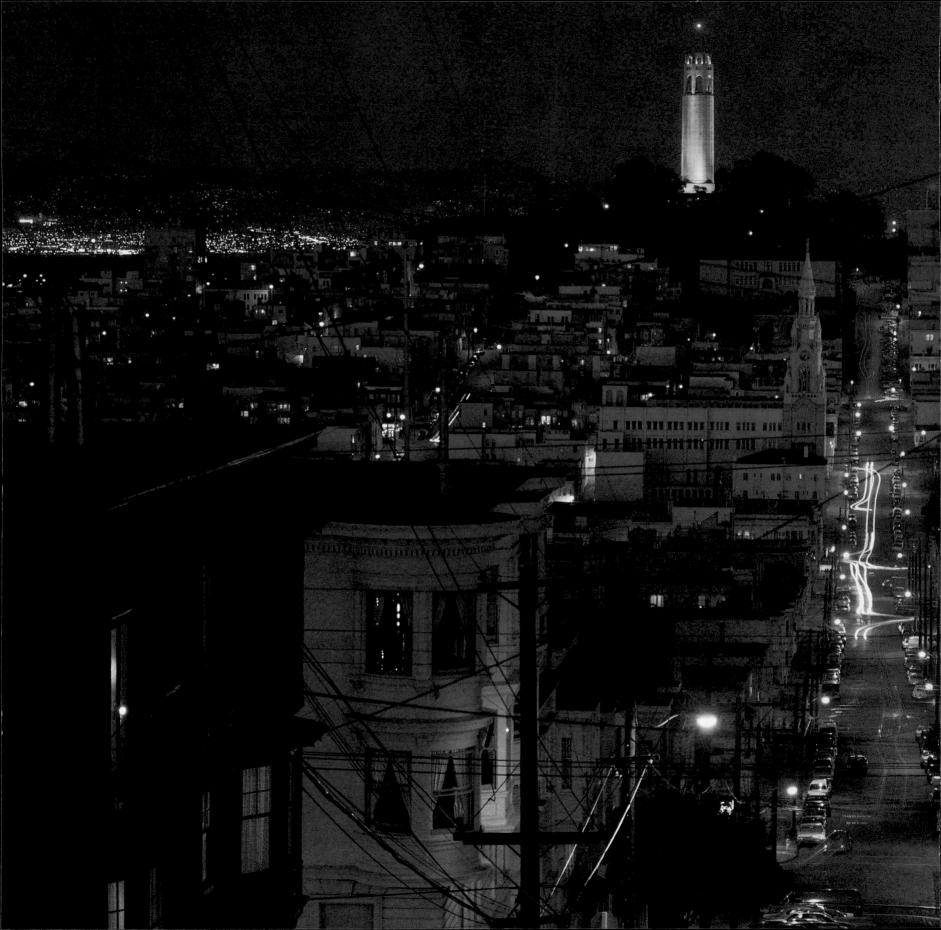

NORTH BEACH

\mathbf{N}orth Beach doesn't have one. Its original sandy shore, along Bay Street, disappeared in the late 19th century, when factories were built on landfill north of the shoreline. There were 5,000 Italian Americans in the city in 1890; fifty years later 60,000 lived in North Beach alone, in a neighborhood that had come to be known as Little Italy. Working-class families lived on narrow alleys, while middle-class families enjoyed the views from apartments on the wider streets. Over the years, Italian families have moved out and Chinese families have moved in, but the pattern has remained.

LEFT

Looking east from Russian Hill toward Telegraph Hill, where Coit Tower, glowing against the night sky, is at the crest. Brightly lit Filbert Street runs past the Church of Saints Peter and Paul; its ornamented spire glimmers with reflected light.

LEFT INSET

Inside the top of 70-foot-tall Coit Tower, a semienclosed observation deck provides an elegant frame for a bird's-eye portrait of downtown. Inside the base of the tower, a team of WPA artists created murals depicting the lives of working men and women in California. The tower was designed by Henry Howard, who envisioned a monument combining the style of the time, Art Deco, and the style of most public monuments, classical.

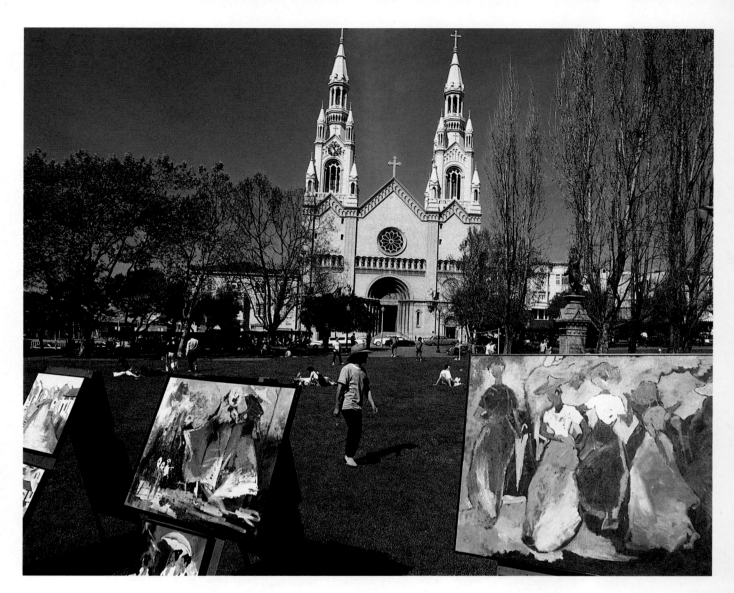

RIGHT

At the Church of Saints Peter and Paul on the north side of Washington Square, Mass is said in English, Italian, and Cantonese. Marilyn Monroe and Joe DiMaggio were married here.

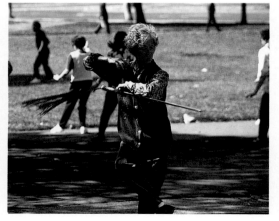

LEFT

In Washington Square — and in Chinatown's Portsmouth Square and numerous other parks in the city — residents gather daily to practice t'ai chi, a Chinese exercise in which a series of understated movements is said to aid circulation, flexibility, balance, and peace of mind.

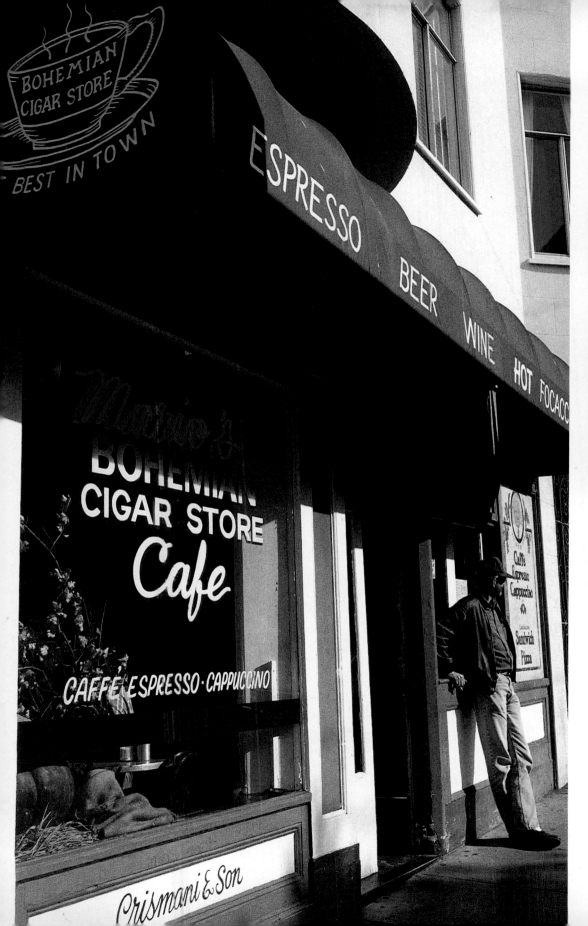

Cafes and specialty shops sell
an assortment of food, collect-
ibles, and everyday merchandise
to visitors and residents of
North Beach.

Inside Cafe Trieste, the
atmosphere is that of the
'50s, when poets talked
politics over endless cups
of espresso; of the '60s,
when idealists talked of
revolution over endless
cups of espresso; and of
the '70s, when dreamers
talked of mind expan-
sion over endless cups
of espresso.

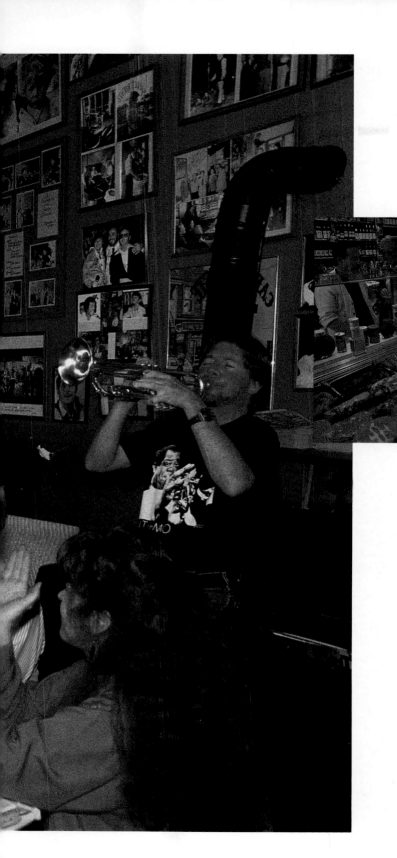

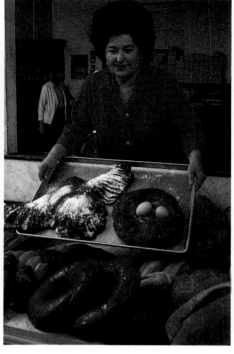

ABOVE

North Beach abounds with
crowded Italian delicatessens,
where the air is pungent
with the smell of aging
cheese and rows of olive oil
cans look like still-life
paintings on the shelves.

ABOVE

Zuccotto, cannoli, panet-
tone, and St. Honore's cake
are difficult on the tongue,
but easy on the palate. The
Italian bakeries of North
Beach survive from the days
when the neighborhood was
a fishing village.

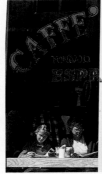

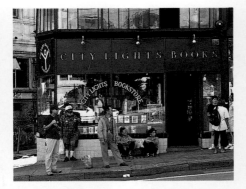

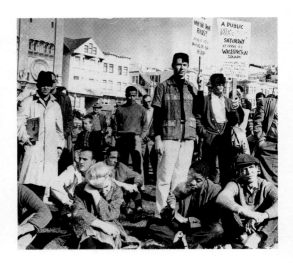

The Beat Generation

In the '50s, the rest of America wore crewcuts and gingham dresses and marveled over the possibilities of atomic power. But in North Beach, Bohemians became Beats and iconoclasts became Beatnik Poets—writers, painters, and musicians who took pride in going against the clean-cut grain of American culture.

In Washington Square, protesters demonstrated against police crackdowns on the counterculture.

The "stars" of the Beat Generation created a lasting literary legacy: Jack Kerouac's *On the Road* and Allen Ginsberg's *Howl* were first read in North Beach in 1955. Poet Lawrence Ferlinghetti, owner of City Lights Books, launched his publishing company with Ginsberg's masterpiece and was prosecuted for having published obscenities. Eventually, author and publisher were acquitted.

Although most Americans viewed the Beats as jaded and world-weary, Ginsberg recalls that the Beats were awestruck by the times. The motif of Kerouac, wrote Ginsberg in 1993, was "the sacredness of the world. This is the only time we're gonna be here, so it's not shit at all and it's not negligible. This is It. And if this is It, what could be more sacred? So you better appreciate it now, while it's here."

ABOVE

Coffee, wine, and books—a combination with the smell and taste of North Beach. Only cigarette smoke is missing nowadays from the original Beat formula.

RIGHT

Broadway, the last gaudy remnant of San Francisco's Barbary Coast, became the heart of honkytonk because of its geographic proximity to the harbor and accessibility to sailors.

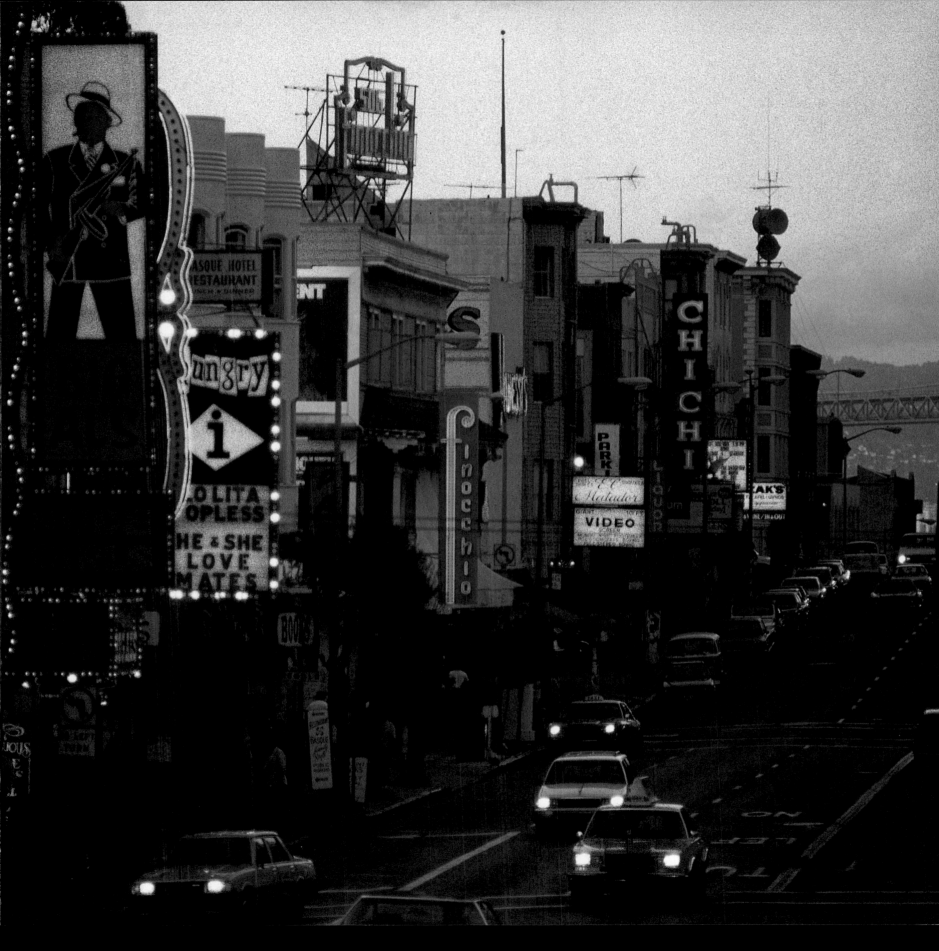

THE HILLS

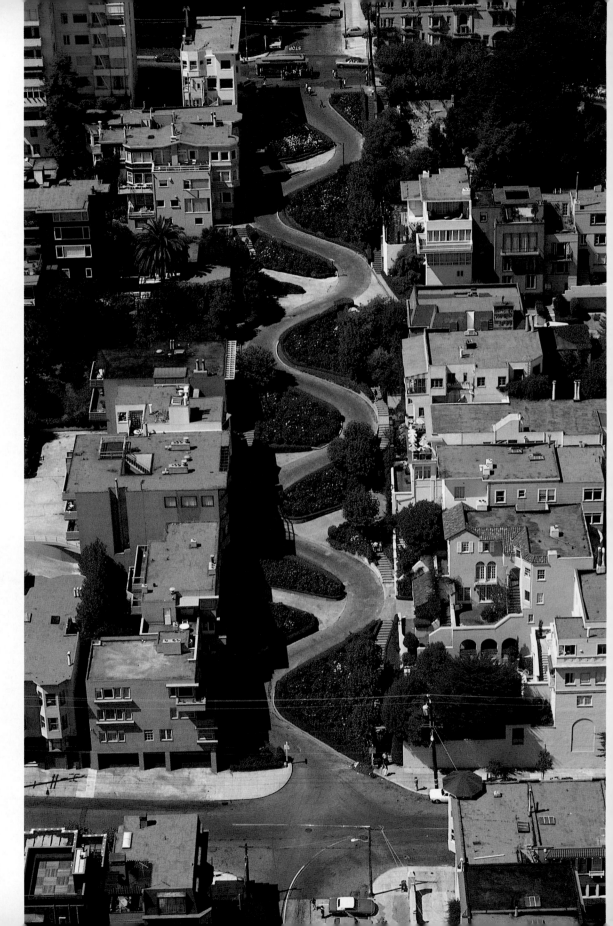

The great mansions of San Francisco were atop Nob Hill, the "Hill of Golden Promise," which was linked to downtown by cable cars in the 1870s. The Victorian mansions were huge, ornate, and, by most critical accounts, tasteless. "It looks as if several architects had been employed," said one critic of a house built by the social-climbing wife of railroad king Mark Hopkins, "and fought each other to the finish."

Russian Hill, possibly the site of a cemetery for seal-hunters, is a quietly elegant residential neighborhood today, but its homes were never as grandiose as those of its neighbor, Nob Hill, nor as fetchingly ramshackle as those on Telegraph Hill, on the other side of Columbus Avenue.

The city's most popular attraction for sightseers is "The Crookedest Street in the World," Russian Hill's Lombard Street. Its eight hairpin turns can be counted in this photo. Potrero Hill's Vermont Street has six tighter turns (not pictured), giving rise to much local debate over which is "crookeder."

On Bay Street, a private cable car carries grocery-laden residents to their dwellings.

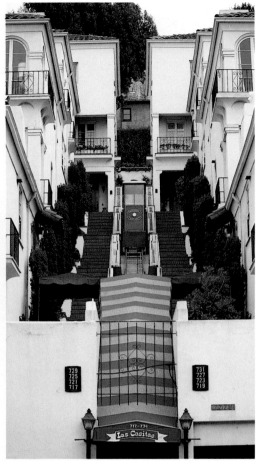

Young artists are trained at the Art Institute on Russian Hill, where visitors may enjoy the Diego Rivera mural in the main gallery, the cafe, and the view.

On Macondray Lane, location of Armistead Maupin's fictional serial *Tales of the City*, most of the buildings have been renovated and remodeled beyond their builders' wildest dreams. Nearby a community garden is tucked into Michelangelo Park on the northern slope of Jones Street.

RIGHT

Nob Hill's Fairmont Hotel is on property once owned by silver mogul James Fair, whose daughter began construction of a 600-room structure in 1902. Its most luxurious suite, a three-bedroom penthouse, includes a tiled game room and a circular library with a ceiling painted as the night sky.

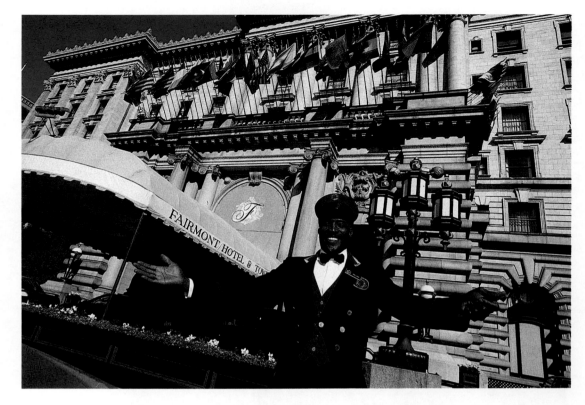

RIGHT

Atop California Street the exclusive Pacific Union Club occupies the 40-room Flood Mansion, which is built of brownstone and therefore the only mansion to survive the earthquake of 1906. Silver baron James Flood employed a full-time staff member whose sole job was to polish the bronze railings.

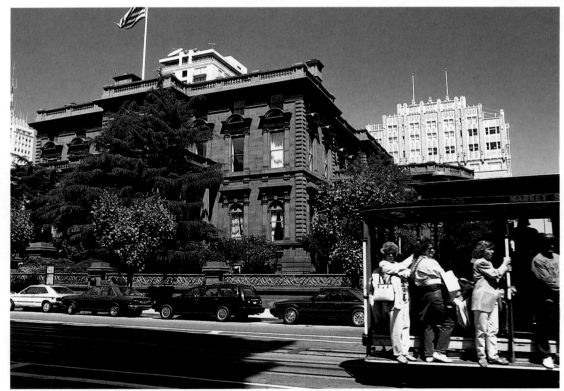

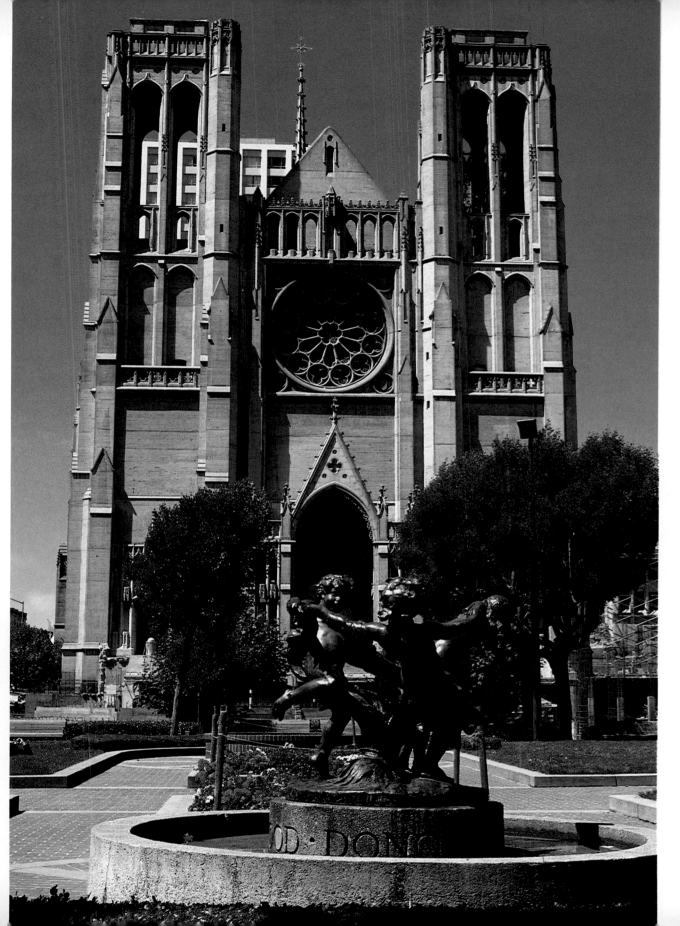

Grace Cathedral Episcopal Church, also on Nob Hill, was modeled after Notre Dame in Paris. Construction began in 1925 and lasted 40 years. Its traditional stained glass is augmented by panels paying homage to such modern icons as Albert Einstein and John Glenn.

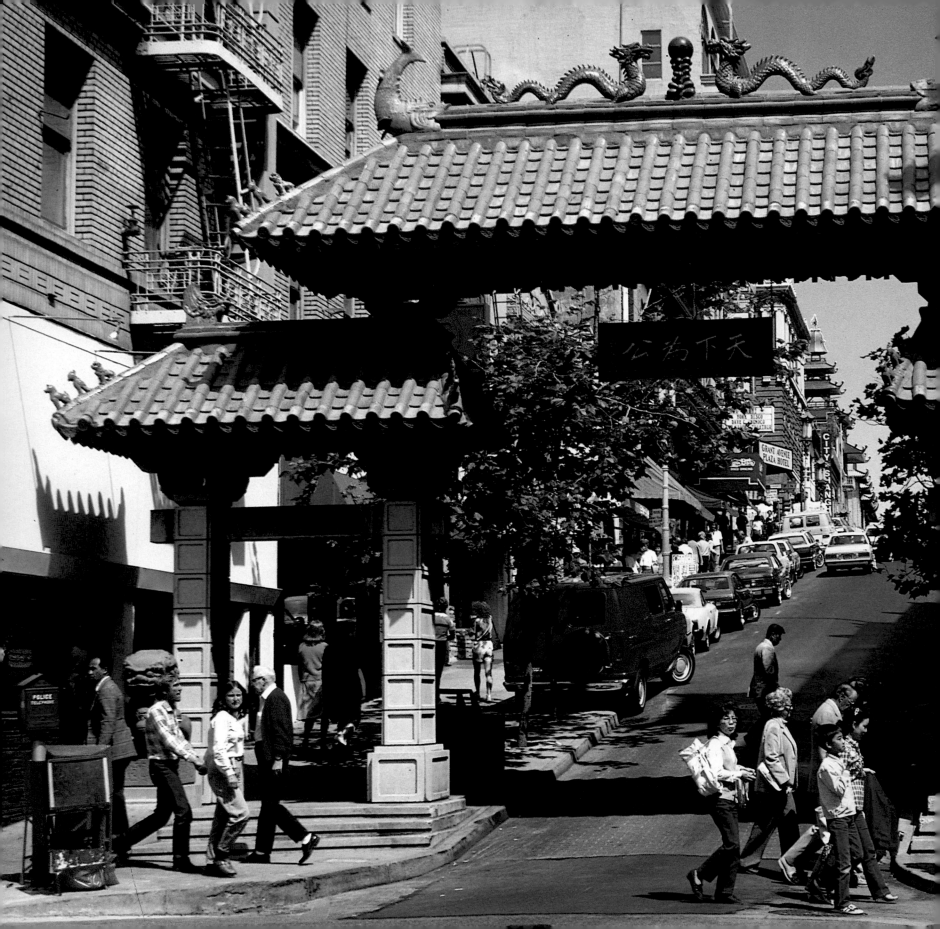

CHINATOWN

*T*he first Chinese came to San Francisco as traders well before the discovery of gold in 1848. When news of the find spread to Asia, Chinese adventurers called Celestials set out for California, which they called the Golden Mountain. From 1850 to the turn of the century, 320,000 Chinese came to California. Those in San Francisco settled in Chinatown, one of the city's oldest districts and the world's largest settlement of Chinese outside Asia. Chinatown grew outward from Stockton Street, the only street on which Chinese were allowed to rent rooms. It took until the late 1940s for Chinese residents to be welcomed into other parts of the city.

LEFT

The Dragon's Gate, the Bush Street portal to Chinatown, was donated to San Francisco by the People's Republic of China in 1969. Two stone lion-dogs at the bases of the pillars of the gate protect against evil spirits.

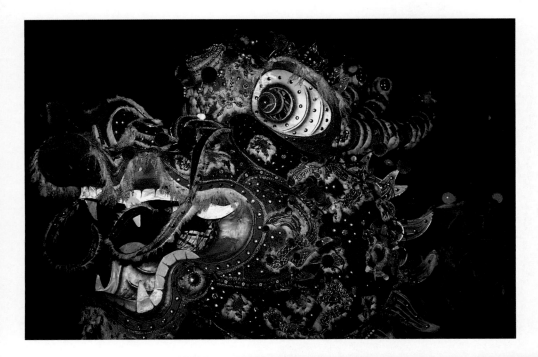

At the Jeng Sen Temple (Buddha's temple) on Waverly Place, visitors leaving donations are presented with calendars in red, the Chinese color of good luck.

ABOVE AND RIGHT

The 150-foot-long dragon centerpiece of the Chinese New Year Parade is carried by 50 people. Lamps light the eyes from within, but the dragon's "vision" comes from a pack of young men that run alongside to guide the beast as it moves through the streets.

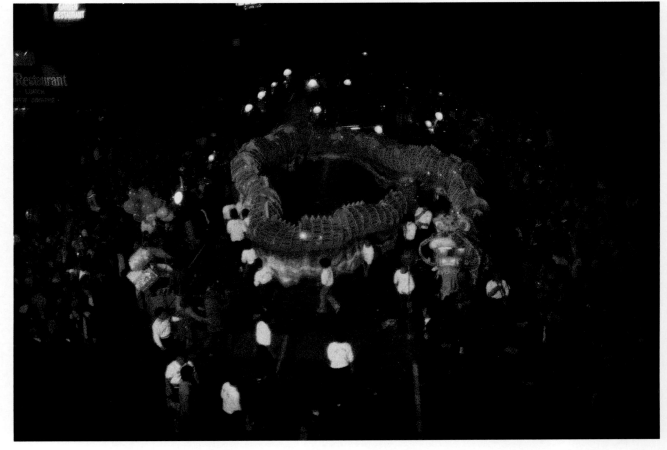

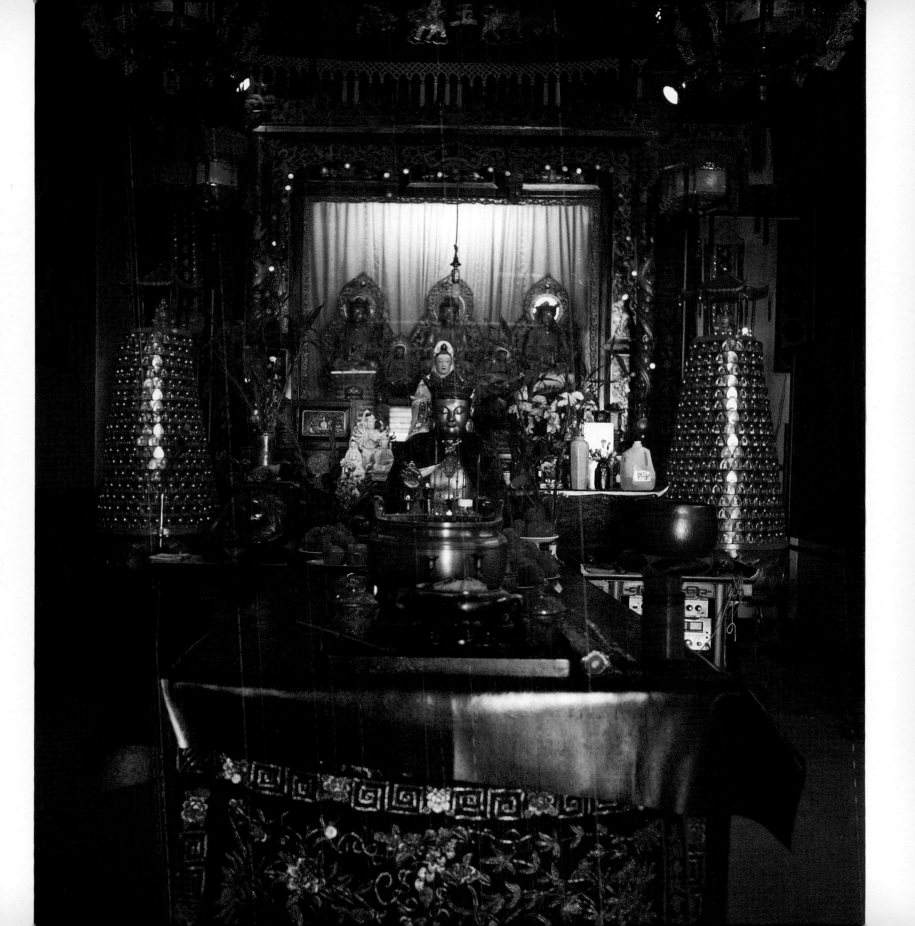

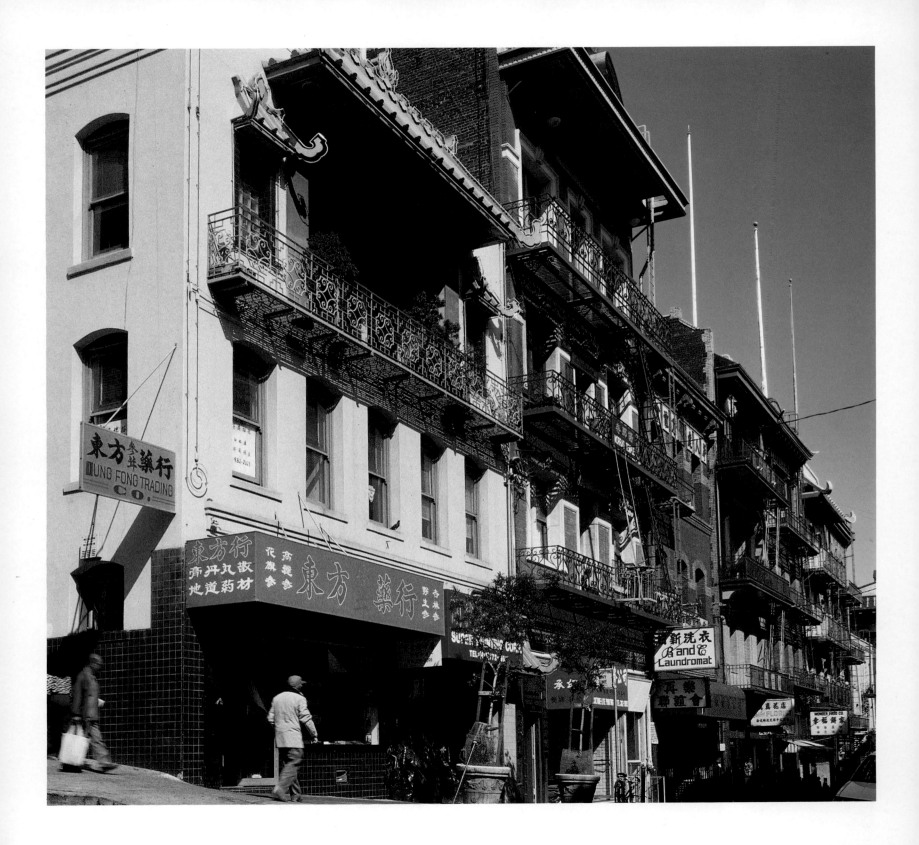

Waverly Place is one of many small alleys in Chinatown where most nontourist business is transacted. At the turn of the century, the street was nicknamed "15 Cents Street," for the price of a barber cutting a pigtail.

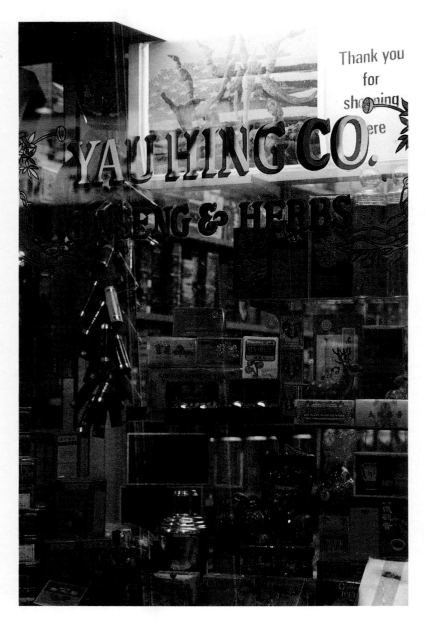

Chinatown herbalists provide ancient remedies for everything from baldness to flatulence, insomnia to impotence— perhaps all in one potion.

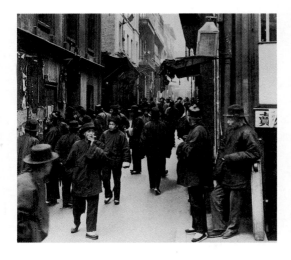

Chinese Laborers and Immigration

During the 1870s and 1880s, most of the Chinese who had left their homeland dreaming of gold in California found themselves pressed into positions as laborers, indentured to pay back the cost of their voyages. Those who remained in San Francisco struggled over a variety of manual and backbreaking jobs.

They worked long hours for low wages, thereby earning little but the resentment of fellow workers who felt their wages were being undercut. In 1880, amid mounting pressure, Congress passed the Chinese Exclusion Act, which denied citizenship to immigrants from China. Four years later, an amendment banned Chinese women from setting foot on American soil.

It wasn't until 1943 that President Franklin Delano Roosevelt asked Congress to repeal the Chinese Exclusion Act, and it wasn't until the War Brides Act of 1946 that Chinese women were free to immigrate.

THE CHANGING CITY

*C*hanges that have swept across San Francisco in the relatively few years since its founding in 1849 are best illustrated in the Western Addition, the central area to the west of Van Ness Avenue.

Here, Victorian survivors of the quake of 1906 stand as reminders of the city's earliest heritage. In Japantown, once a 40-block neighborhood, urban redevelopment has replaced blocks of low-income housing with shopping facilities. An imposing synagogue on California Street recalls the Forty-Niners whose first place of worship was a tent on downtown Jackson Street.

The downtown skyline forms a backdrop for the row of perfectly matched Victorians on Steiner Street hill at Alamo Square.

86

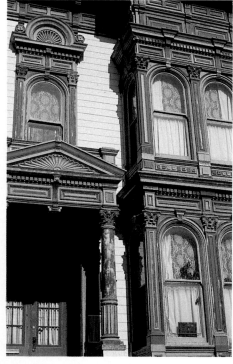

LEFT

Although many Victorian houses are now painted in bright hues, their original color schemes were often sedate browns and grays, in keeping with the general public reserve of the Victorian era.

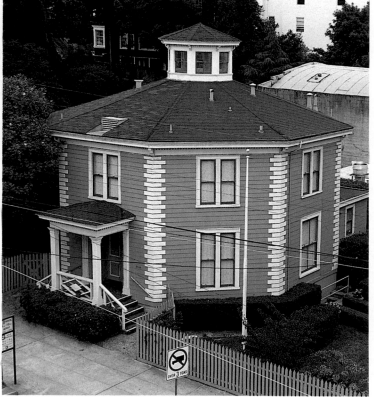

ABOVE

The Haas-Lilienthal House on Franklin Street, built in 1886, is headquarters for the San Francisco Architectural Heritage Foundation.

RIGHT

The Octagon House at Gough and Vallejo is one of two remaining eight-sided structures in the city. The architect's aim was to ensure that every room received equal amounts of sunlight.

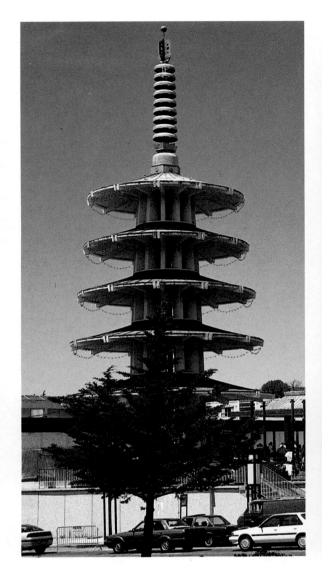

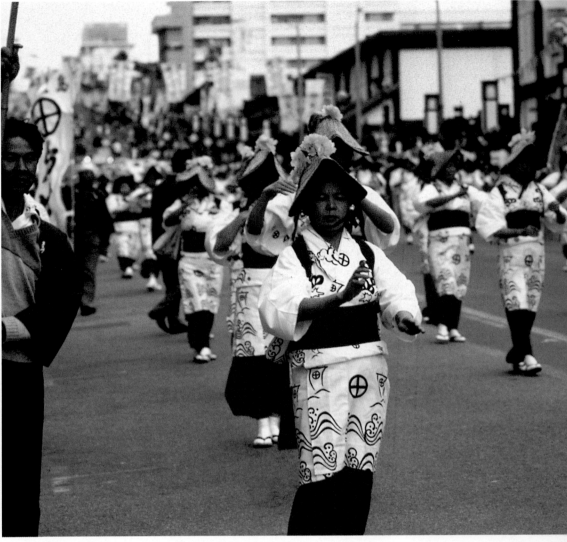

ABOVE

The center of Japantown is the Peace Pagoda, a gift from the Japanese residents of San Francisco. While many of its original residents have moved away, Japantown is still used for traditional ceremonies and serves as a shopping center for delicacies unavailable elsewhere.

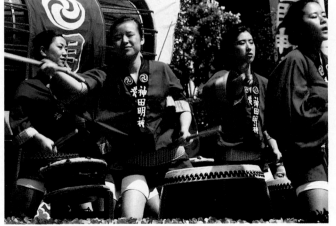

ABOVE AND LEFT

Parades are held for the Cherry Blossom Festival, Obon dances, and the Aki Matsuri Festival, when the booming beat of Taiko drums reverberates through the streets.

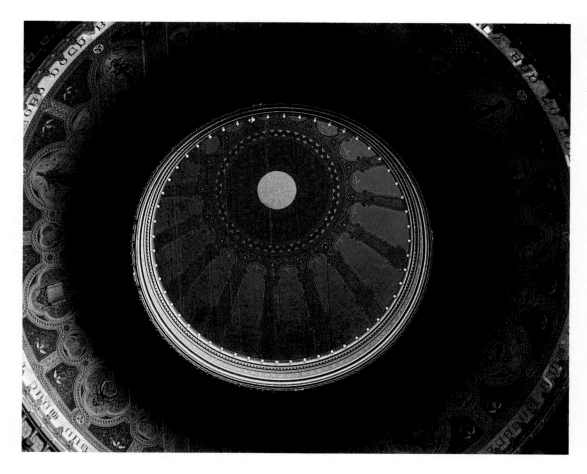

The dome of the Sherith Israel Synagogue, its interior lavishly painted in lush patterns, is a California Street landmark. The building, constructed in 1904, was used as a temporary city hall after the 'quake of 1906 and is open to the public for periodic tours. The first Jewish services in San Francisco were held in a tent in 1849.

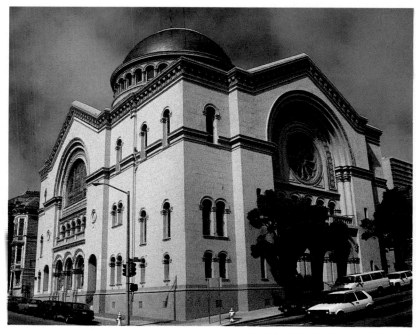

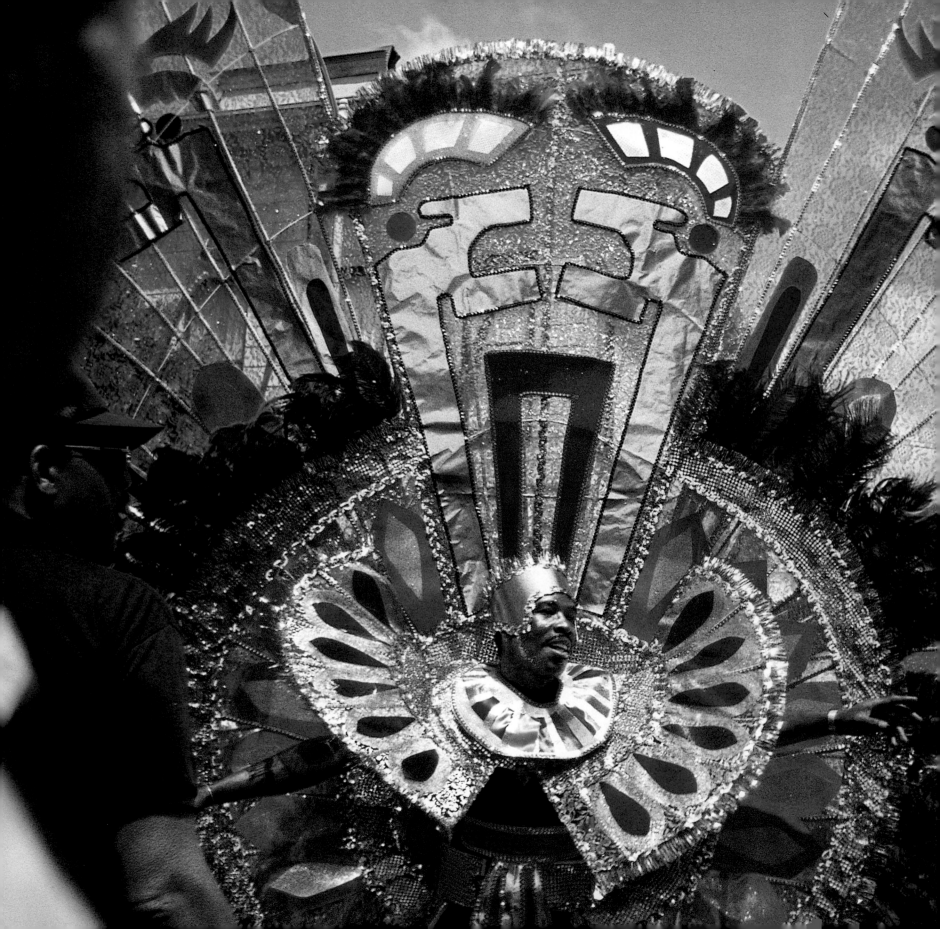

THE MISSION

ABOVE

Golden details
enrich a series of
colorful murals on
24th Street.

At the heart of San Francisco's thriving, throbbing Mission District is Mission Dolores, an oasis of quiet dignity. Built by Franciscans and completed in 1791, it is the oldest building in the city and contains an array of architectural elements—doors from the Philippines, altar parts from Mexico— that are evidence of the global reach of Spain in the 18th century. Like the mission itself, the Mission is a neighborhood comprised of many Latino elements, including the largest settlement of Central Americans outside of their homelands. A walk along Mission Street is a stroll through Mexico, Colombia, Guatemala, Nicaragua, and El Salvador. Thanks to topography—and the neighborhood's ambience—it's the warmest place in San Francisco.

LEFT

Carnival, a street celebration
of ethnic pride in the Latino
community, takes place in
the Mission District in early
summer. Samba schools
sponsor floats and a corps of
dancers, who snake their way
through the huge crowds
of spectators.

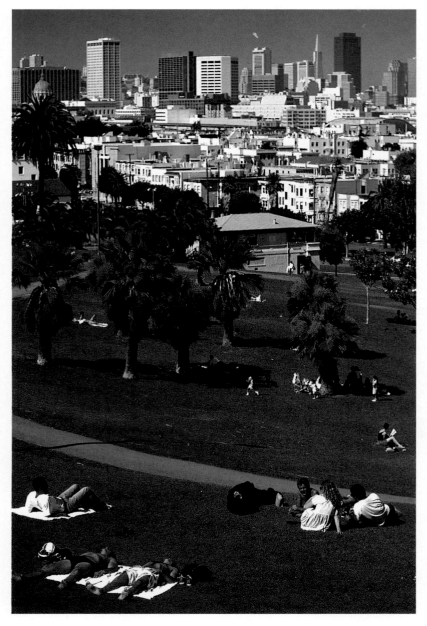

The Mission District's
Dolores Park contains a
concrete replica of Mexico's
liberty bell and a bronze
statue of Miguel Hidalgo y
Castilla, the George Wash-
ington of Mexico.

RIGHT

The adobe structure of Mission Dolores, built in the
late 18th century, was later covered with hard cement
stucco to protect it from the rain. The ceiling of the
mission is patterned after basket designs of the Native
American Costanoans.

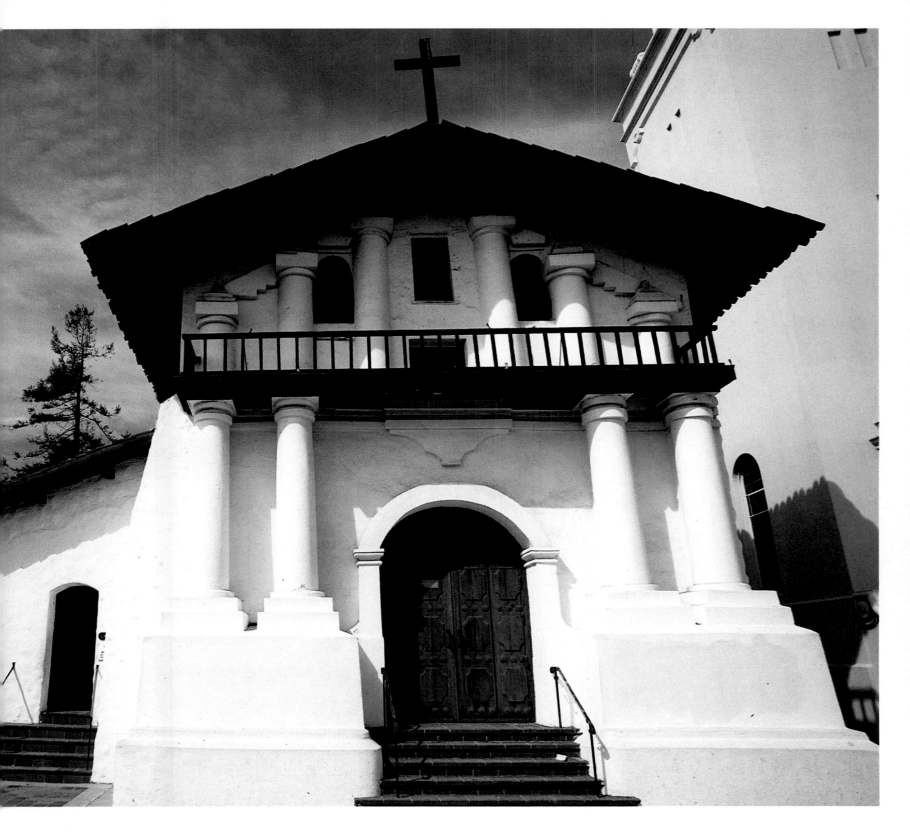

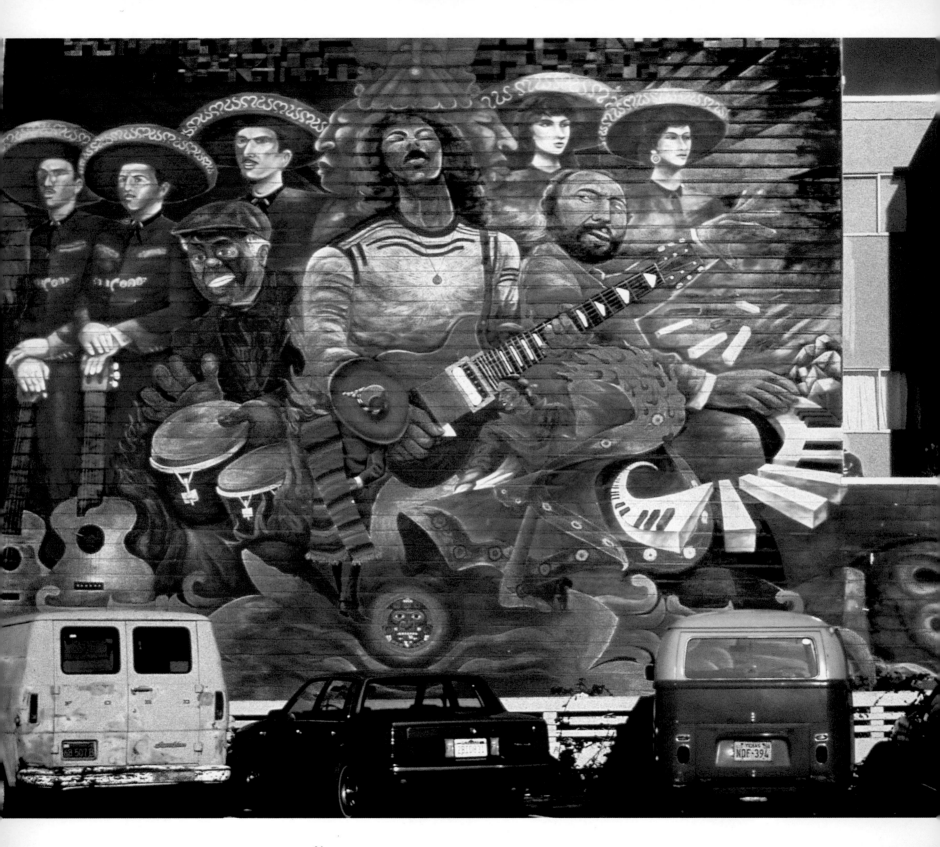

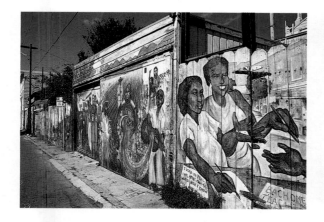

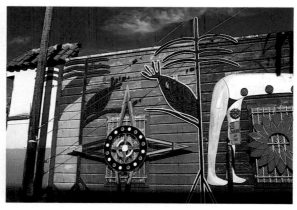

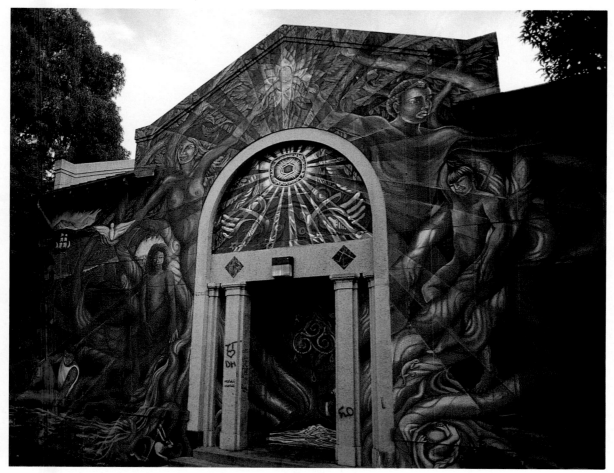

Most of San Francisco's 450 outdoor murals are in the Mission District. The tradition of "people's art" comes from European churches and from Mexico, home of such well-known practitioners as Diego Rivera and Jose Clemente Orozco.

THE CASTRO
AND BEYOND

The Castro District, beginning about halfway along Market Street's slash through the city, was part of a Mexican-owned ranch until 1854, when it was subdivided and sold in individual parcels. Later the Market Street Railway was extended to Castro Street and turned a suburban neighborhood into an urban, working-class neighborhood. Today, the area is the best-known gay district in the United States, with a busy commercial stretch centered on Castro Street. Up the hill, once-inexpensive Victorian cottages are now pricey and meticulously maintained.

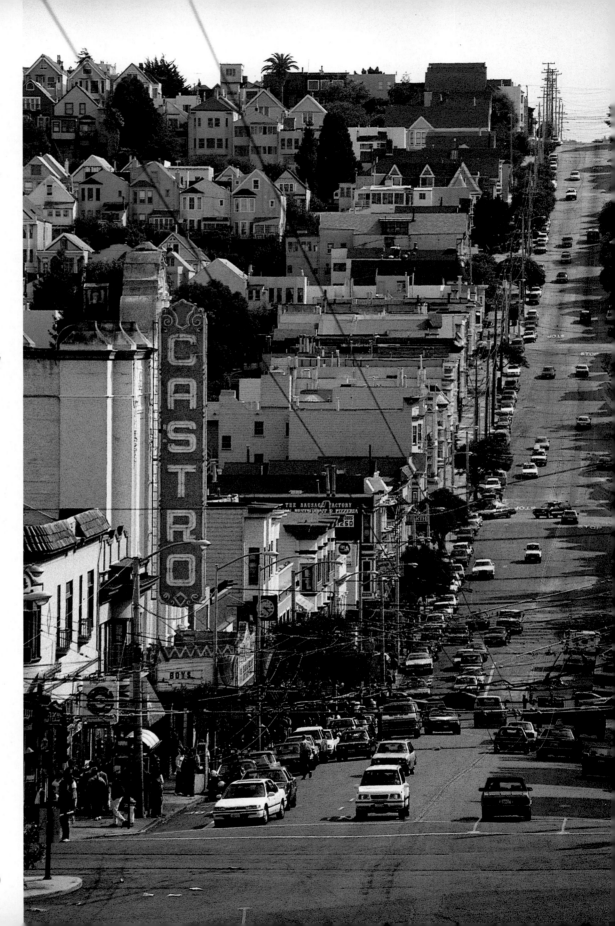

The rainbow banner, symbol of gay pride, flies outside many windows.

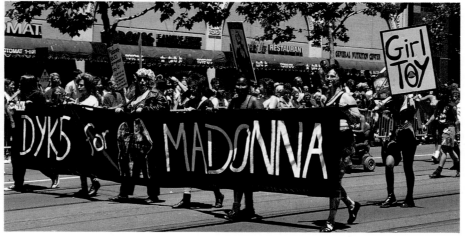

Thousands of gays and lesbians converge every year for Gay Freedom Day, which culminates in a parade down Market Street. The event includes elements of joy, in its celebration of gay pride, and sorrow, in its remembrance of those fallen to AIDS.

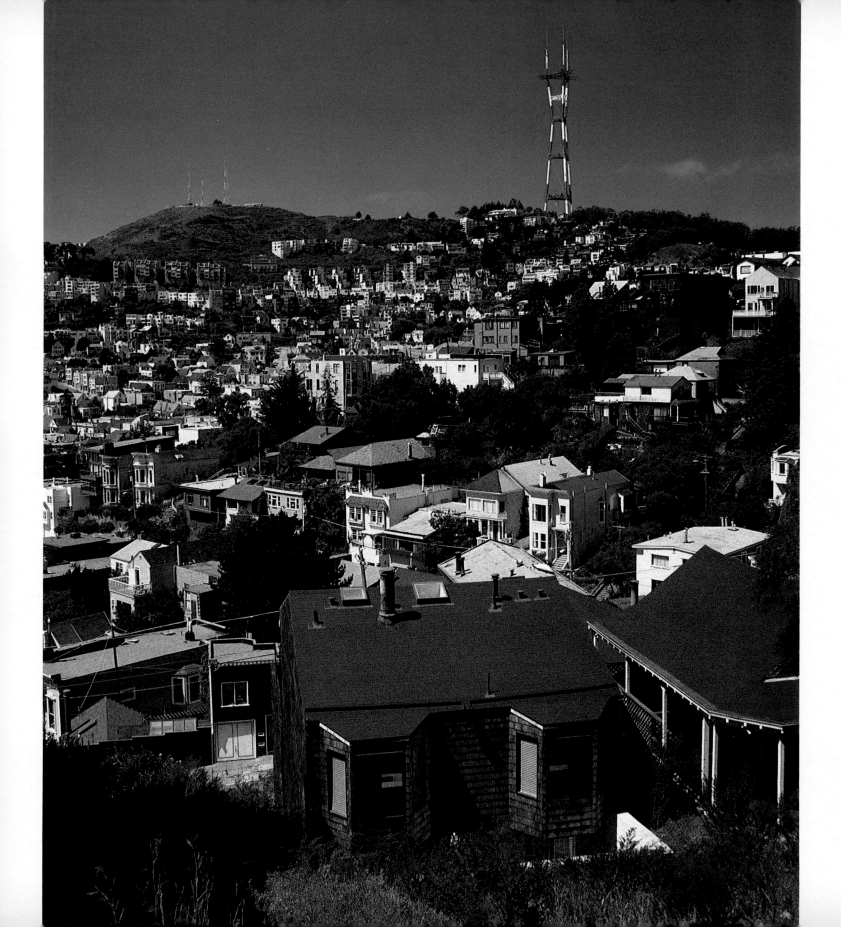

The Saturn Steps, near Roosevelt Way and 17th Street, offer a sweeping view toward downtown.

Just a few paces away, the Vulcan Steps are bordered by flower beds tucked among crowded cottages. Close by, but not pictured, the Josephine Randall Museum near Buena Vista Park has exhibits for children, including petting pens stocked with birds, rabbits, and other animals that like to be cuddled.

Residents of the Upper Market Street area fought the construction of the red-and-white-striped Sutro Tower on the grounds that it was ugly. The broadcast tower has become part of the landscape—but has ruined TV and video reception for nearby homes.

THE HAIGHT

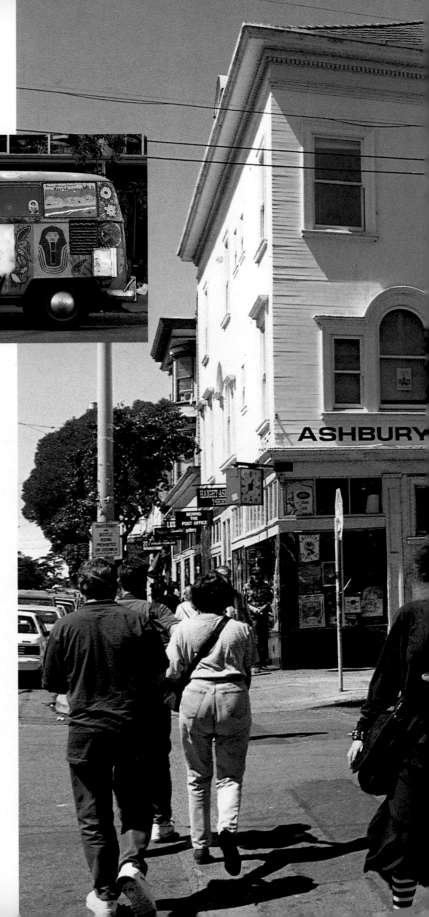

The Haight-Ashbury District, which lies at the eastern tip of Golden Gate Park, contains more than a thousand Victorian houses. During World War II, when multitudes of Americans came to San Francisco to work in its shipyards, the large Victorians were split into small apartments and rooming houses. Low rents made the neighborhood a mecca for Beat refugees from North Beach and, 10 years later, for hippies that converged for the Summer of Love. Rampant drug use turned the neighborhood into what was called a "psychedelic ghetto." Just when it was at its worst, of course, optimistic young people started moving back in, taking advantage of the low prices to buy up gracious homes. Walking down Haight Street today, the layers of the neighborhood "onion" are still visible: aging hippies, teenage runaways, and affluent young professionals are endlessly defining the Haight in their own terms.

ABOVE

The Haight abounds with art cars, as the Mission abounds with murals. Vehicles are apt to be painted in homage to artists such as Dali and Van Gogh, emblazoned with political messages or festooned with sculptural "junk." One car has a caved-in roof and a license plate imprinted with the exact time of the 1989 quake.

RIGHT

The street signs at the corner of Haight and Ashbury streets were stolen by souvenir hunters with such regularity that eventually the names of the streets were painted on the corner building.

100

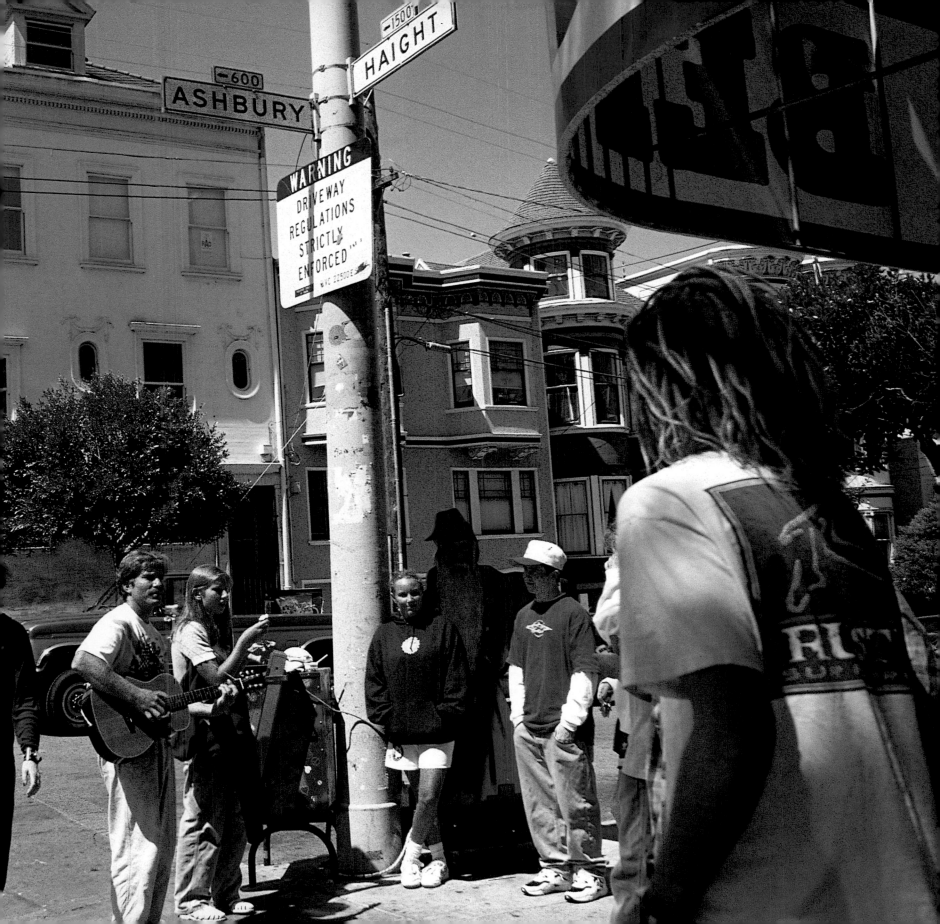

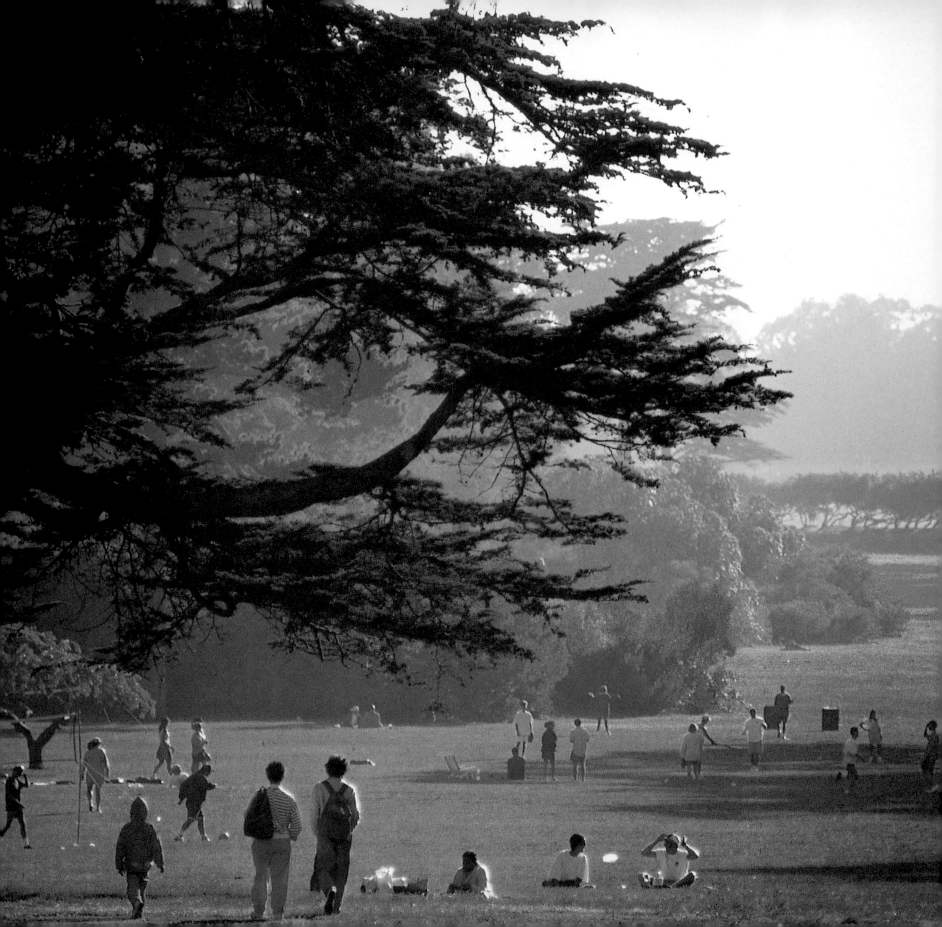

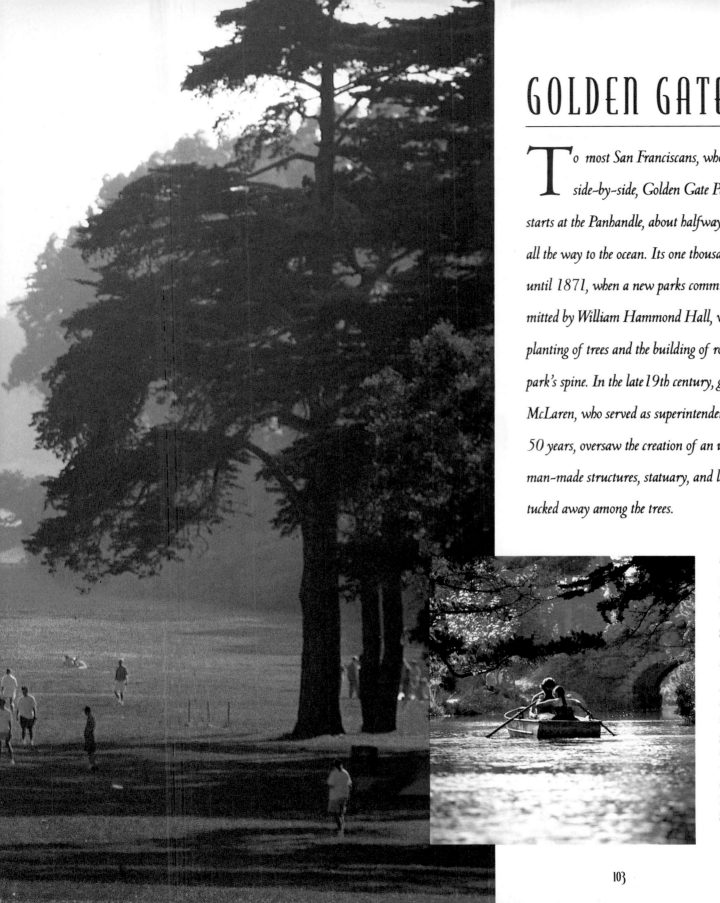

GOLDEN GATE PARK

To most San Franciscans, who live in houses pressed together side-by-side, Golden Gate Park is the country. The park starts at the Panhandle, about halfway through the city, and extends all the way to the ocean. Its one thousand acres were sand dunes until 1871, when a new parks commission approved a design submitted by William Hammond Hall, who then supervised the planting of trees and the building of roads that would become the park's spine. In the late 19th century, gardener and planner John McLaren, who served as superintendent of the park for more than 50 years, oversaw the creation of an urban wilderness, with its man-made structures, statuary, and leisure facilities carefully tucked away among the trees.

FAR LEFT

Links of meadows stretching west through Golden Gate Park to the Pacific form a grassy playground two miles long.

LEFT INSET

At Stowe Lake, instant sailors can rent rowboats, gently powered motorboats, or pedal boats, and glide through flocks of ducks and swans. Elsewhere on summer weekends, music-loving picnickers flock to Stern Grove on Sloat Boulevard for free concerts every Sunday afternoon.

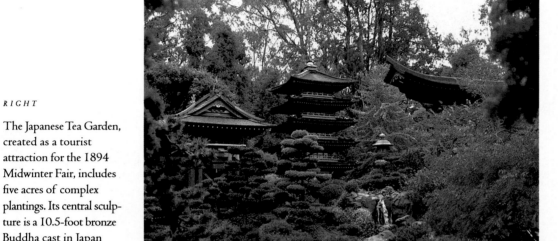

The Japanese Tea Garden, created as a tourist attraction for the 1894 Midwinter Fair, includes five acres of complex plantings. Its central sculpture is a 10.5-foot bronze Buddha cast in Japan in 1790.

RIGHT

Millionaire James Lick ordered a prefabricated glass structure from Ireland in 1875 for his estate in San Jose. He died before he could build it, and the fabulous greenhouse was donated to the park, where it became the Conservatory of Flowers.

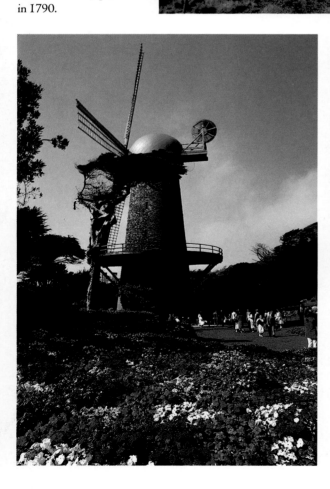

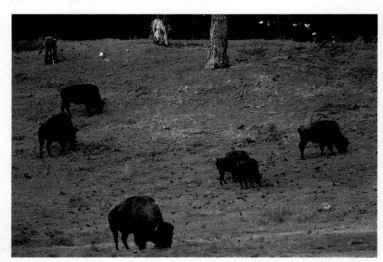

LEFT

Windmills built at the western edge of Golden Gate Park around the turn of the century made use of sea breezes to pump water—as much as 100,000 gallons per hour—from subterranean rivers to irrigate the park.

ABOVE

The buffalo of Golden Gate Park used to be named for Shakespearean characters. In the early 1990s, they were rechristened with Native American names, making historical reference to the era in which they roamed the west in peaceful coexistence with human inhabitants.

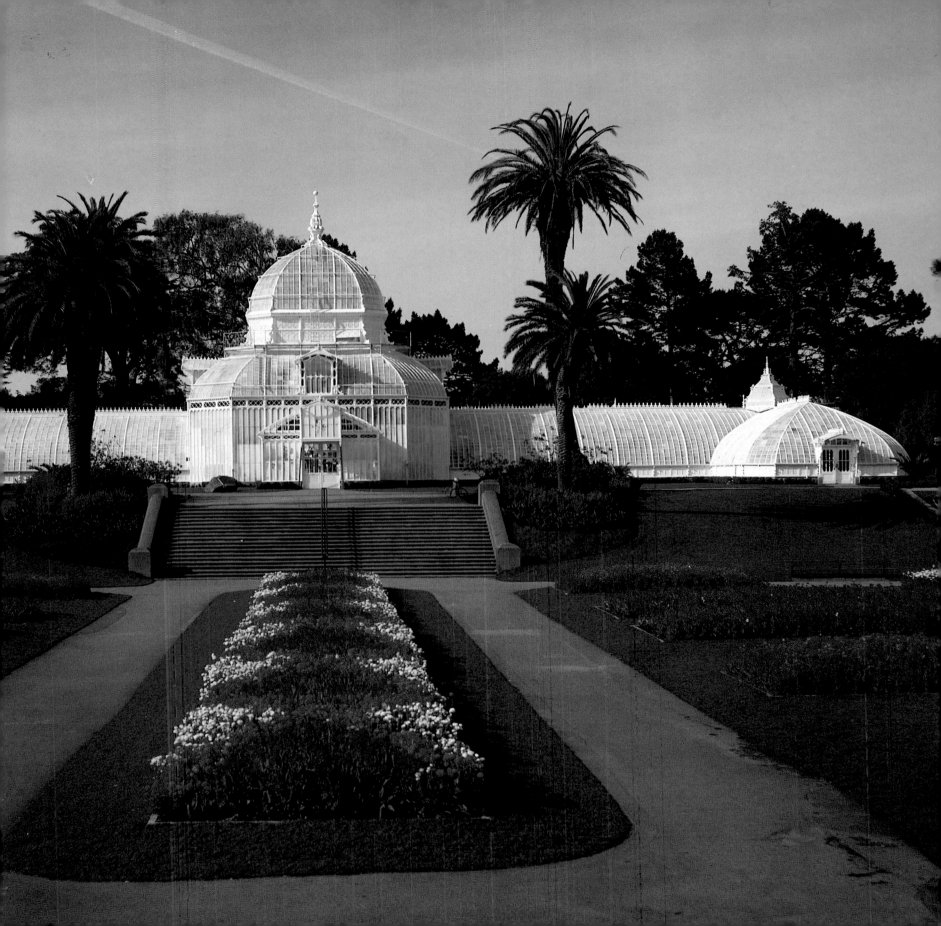

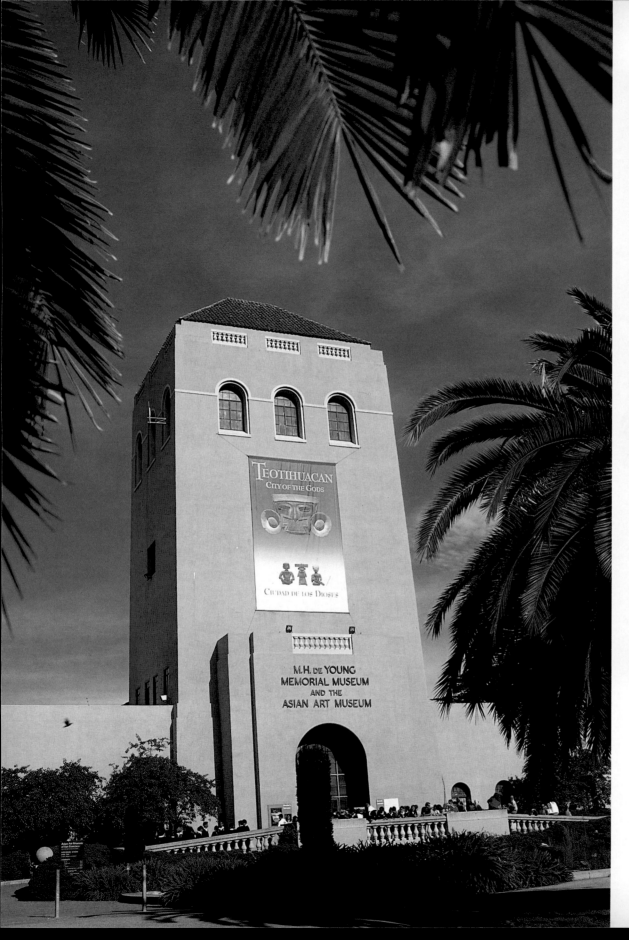

LEFT

The M.H. de Young Memorial Museum is in an Egyptian-style building constructed for the 1894 Midwinter Fair. It houses a major collection of American art.

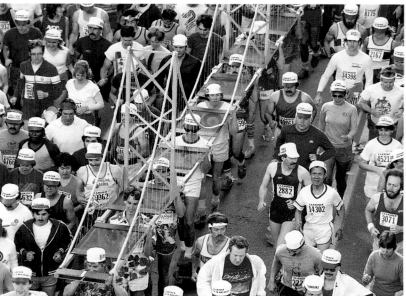

The eastern end of Golden Gate
Park is closed to traffic on
Sundays, when cyclists and skaters
hit the roads. The flashiest figure
skaters congregate on Kennedy
Drive near the Conservatory of
Flowers and just south of Sixth
Avenue and Fulton Street.

More than 100,000 "competitors," including serious
seeded runners and hordes of wildly costumed joggers,
strollers, striders, hoppers, skippers, and jumpers, run
the 7.5-mile Bay to Breakers race on the third Sunday in
May. The race starts near the foot of the Bay Bridge and
continues west through Golden Gate Park, ending at the
Pacific Ocean.

THE AVENUES

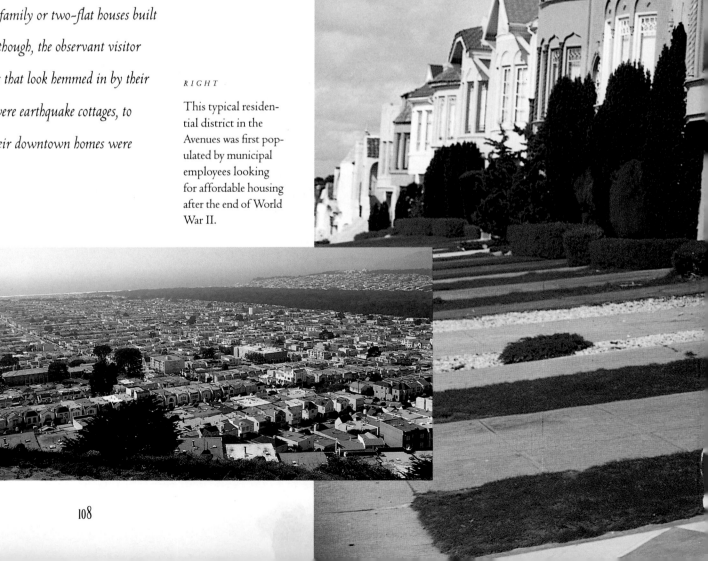

The Richmond and Sunset districts extend for more than 40 blocks along the northern and southern sides, respectively, of Golden Gate Park to the ocean. The neighborhoods are referred to as the Avenues because the cross streets, quiet and residential, are numbered 2nd to 48th avenue. (The major numbered thoroughfares downtown are called Streets.) Architecturally, the Richmond and Sunset neighborhoods are roughly similar, featuring rows of single-family or two-flat houses built after the '20s. Every few blocks, though, the observant visitor will notice ramshackle bungalows that look hemmed in by their more imposing neighbors. These were earthquake cottages, to which many families fled after their downtown homes were destroyed in the quake of 1906.

RIGHT

This typical residential district in the Avenues was first populated by municipal employees looking for affordable housing after the end of World War II.

RIGHT

The panoramic view from Sunset Heights Park near Quintara and 14th Avenue takes in the Sunset and Richmond districts and the swath of Golden Gate Park that divides them.

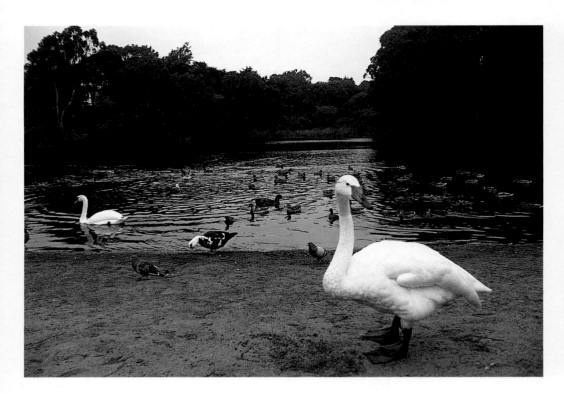

ABOVE

Mountain Lake Park, a slash of water, playgrounds, and fields, extends along the southern edge of a former military station.

RIGHT

Lake Merced, at the southwest corner of the city, is used for daily windsurfing and regular predawn crew practice; the perimeter of the lake has a popular trail for joggers, hikers, and cyclists.

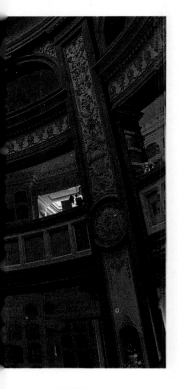

The Colombarium of
Lorraine Court in the
Richmond District is
all that remains of four
cemeteries that once
dominated the neighbor-
hood. When the land was
needed for housing, the
cemeteries were relocated
to Colma, a suburb south
of the city.

Holy Virgin Cathedral on outer Geary Street is one
of several Russian churches found in the Avenues.
A wave of White Russian immigrants arrived after
the 1917 revolution and World War I, many having
traveled eastward through Asia. They settled in the
Richmond District, where the neat streets and
quiet residential atmosphere provided refuge from
the turbulence from which they fled.

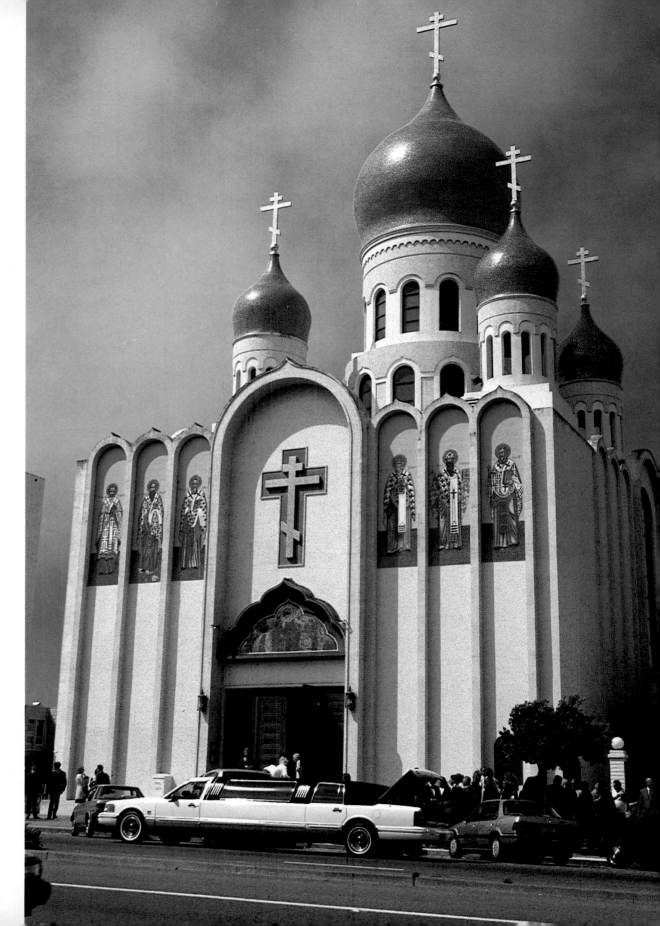

PALACE OF THE LEGION OF HONOR

San Francisco owes its most picturesque museum, the Palace of the Legion of Honor, to Alma Spreckels, whose mother was a laundress and whose husband was the enormously rich sugar baron Adolph Spreckels. Perhaps because Mrs. Spreckels was the descendant of a French general, she was a lifelong Francophile. After a 1914 visit to France, she persuaded her husband to finance an art museum dedicated to the promotion of French art. The city donated the land, a scenic parcel near its northwest corner, at the crest of a curving hill overlooking the Golden Gate and the downtown skyline. Mrs. Spreckels directed that the museum building, completed in the '20s, be modeled on the 150-year-old Palais de la Legion d'Honneur in Paris. Opening ceremonies for the Palace, dedicated to California soldiers who had died in France during World War I, were held on Armistice Day, 1924, and were attended by French military officials as well as local dignitaries.

An arched entryway leads visitors into the Palace of the Legion of Honor.

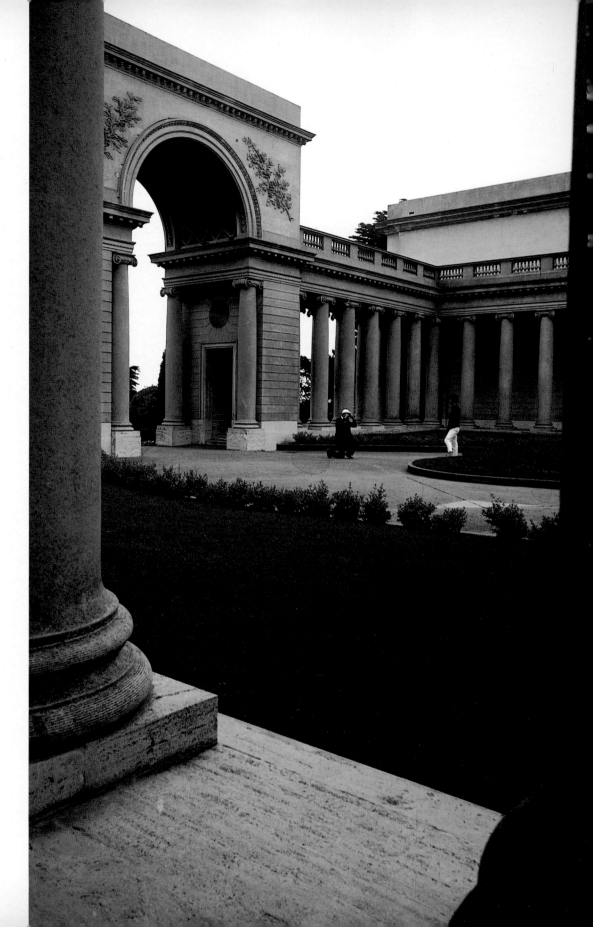

Among the 700 pieces of art in the original collection at the Palace were 31 Rodin sculptures on loan from Alma Spreckels. The museum's collection currently includes 106 Rodin sculptures, including a reproduction of "The Thinker," who greets visitors in the Palace courtyard.

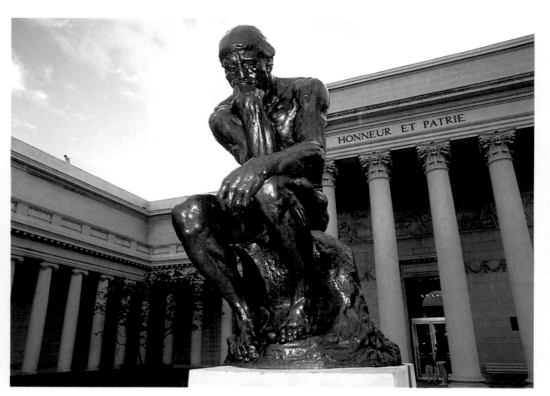

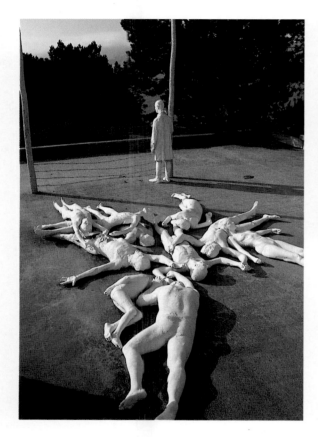

ABOVE

The Holocaust Memorial by George Segal is a shocking sculpture whose effect is heightened by its sylvan setting.

RIGHT

Lincoln Park, with green hills rolling toward downtown from the front yard of the Palace, was once a pauper's cemetery.

The Cliff House

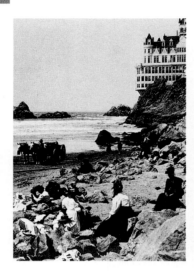

There was little business at the Cliff House in 1863, its first year of operation, because it took travelers so long to get there from downtown. Within two years, however, a highway along the beach (today the Great Highway) had been completed, and San Francisco's most fashionable trendsetters were setting out for the Cliff House as a day's outing.

If it's hard to park today, there may be some comfort in knowing that this was always the case. As many as 1,200 carriages would be hitched in front of the Cliff House on a weekend day, with hundreds turned away for lack of space. The number of customers increased as public transportation was extended to the ocean, making the Cliff House accessible to all San Franciscans.

But the building at land's edge seemed to be cursed. In 1887, a schooner crashed into its foundations, causing an explosion that demolished a large section. Seven years later, a fire on Christmas Day destroyed the whole building.

Two years later, the same year that work began on nearby Sutro Baths, a new Cliff House, a grand seven-story structure, was built by Adolph Sutro, whose mansion overlooked the site. Sutro's 10-year-old Gingerbread Palace survived the earthquake of 1906 — and accommodated such famous overnight guests as Sarah Bernhardt, Mark Twain, and Theodore Roosevelt — but didn't make it much longer than that. It burned to its foundations in September 1907.

As if taking warning from the string of disasters that had befallen the Cliff House, the sea lions of Seal Rock swam off to the Farallon Islands after the 1907 fire. They stayed away for two years, not returning until well after a third Cliff House had opened to the public. They've been back ever since, oblivious to the clicking shutters, slithering in and out of the sea, and waddling around their rock.

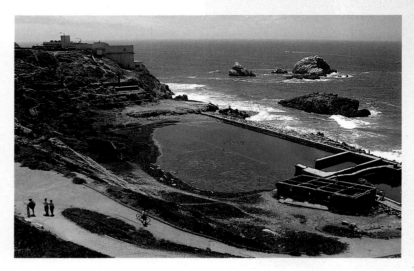

ABOVE

Only ruins remain of the once-elegant Sutro Baths, a huge public swimming establishment just north of the Cliff House. The glass-canopied structure, originally built in 1896, contained seven heated pools and was destroyed by fire in 1960.

RIGHT

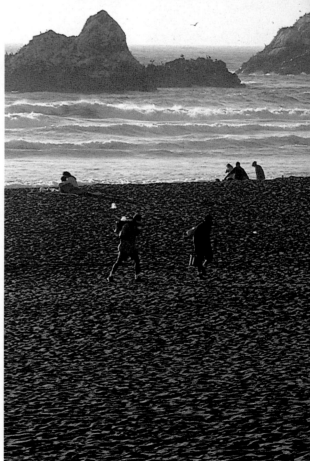

The Cliff House, as it appears today, overlooks Seal Rock, which was deeded to San Francisco by Congress in 1887. Just below the Cliff House, at the edge of the ocean, are the Musée Mécanique, which contains an array of coin-operated antique amusement park toys, and the Camera Obscura, a version of the optical darkroom curiosity created by Leonardo da Vinci.

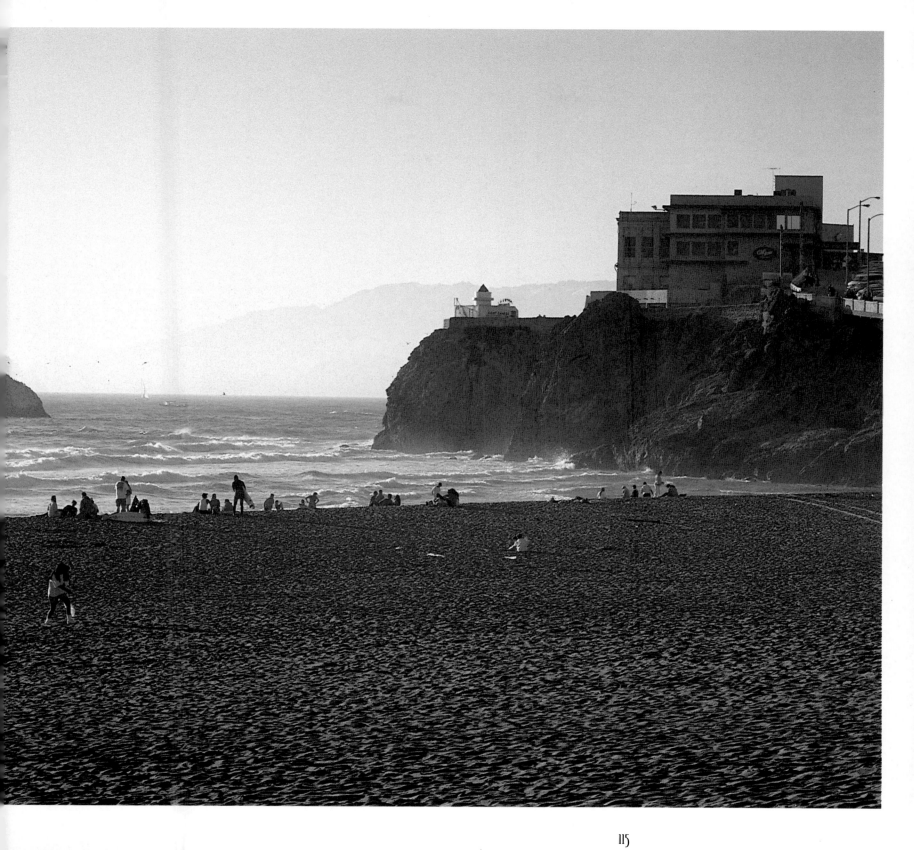

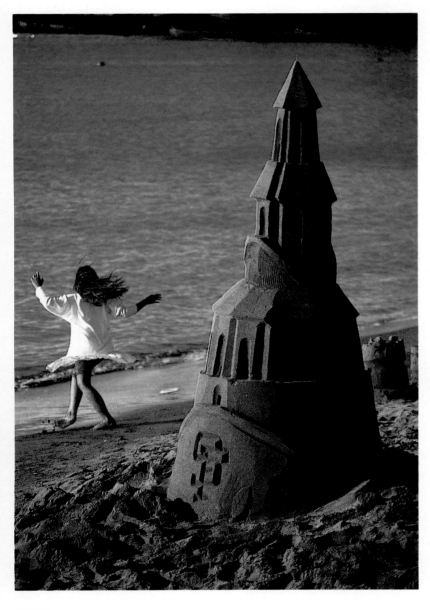

ABOVE

At Aquatic Park, teams
of architects and school-
children compete in an
annual sandcastle contest.
Year round, the temperature
of the water in the bay and
the ocean is too cold for
frolicking in the surf, but
children and wet-suited
surfers don't seem to mind.

RIGHT

At Fort Funston, a hang glider leaps from the cliff,
catches a current of wind, and soars over the surf.
Hidden in the hills at the fort are dismantled artillery
turrets and pillboxes constructed to guard the coast
during World War II.

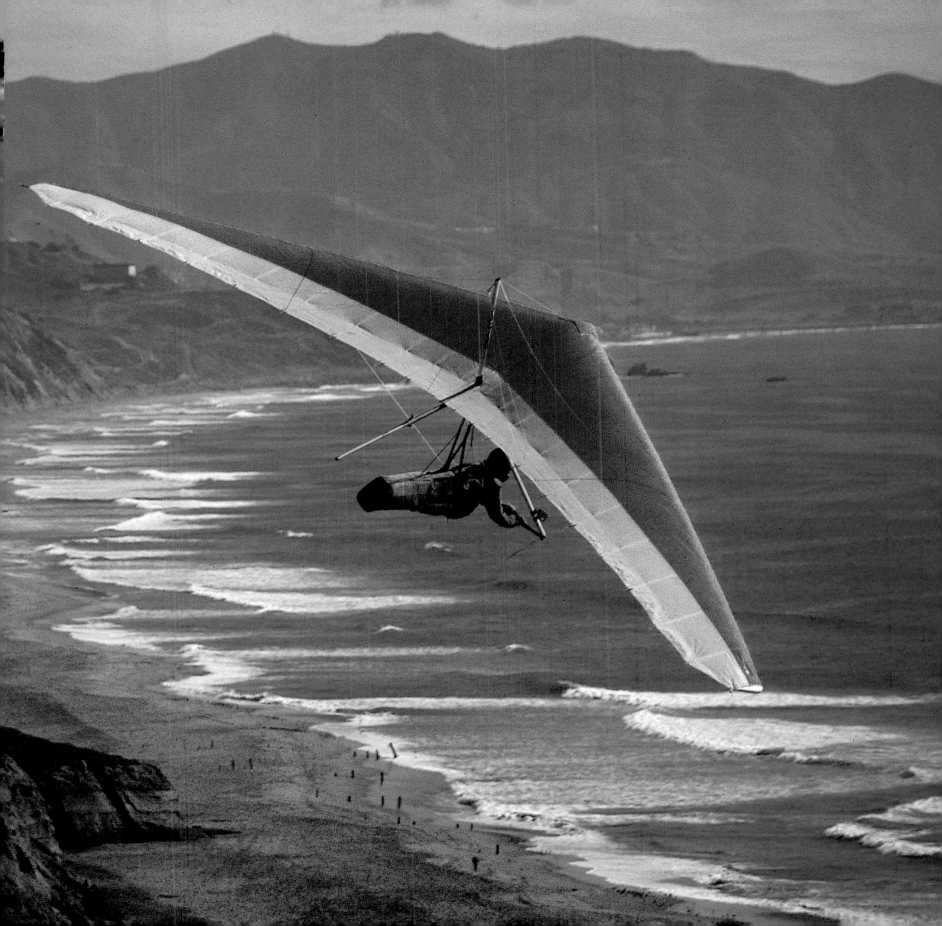

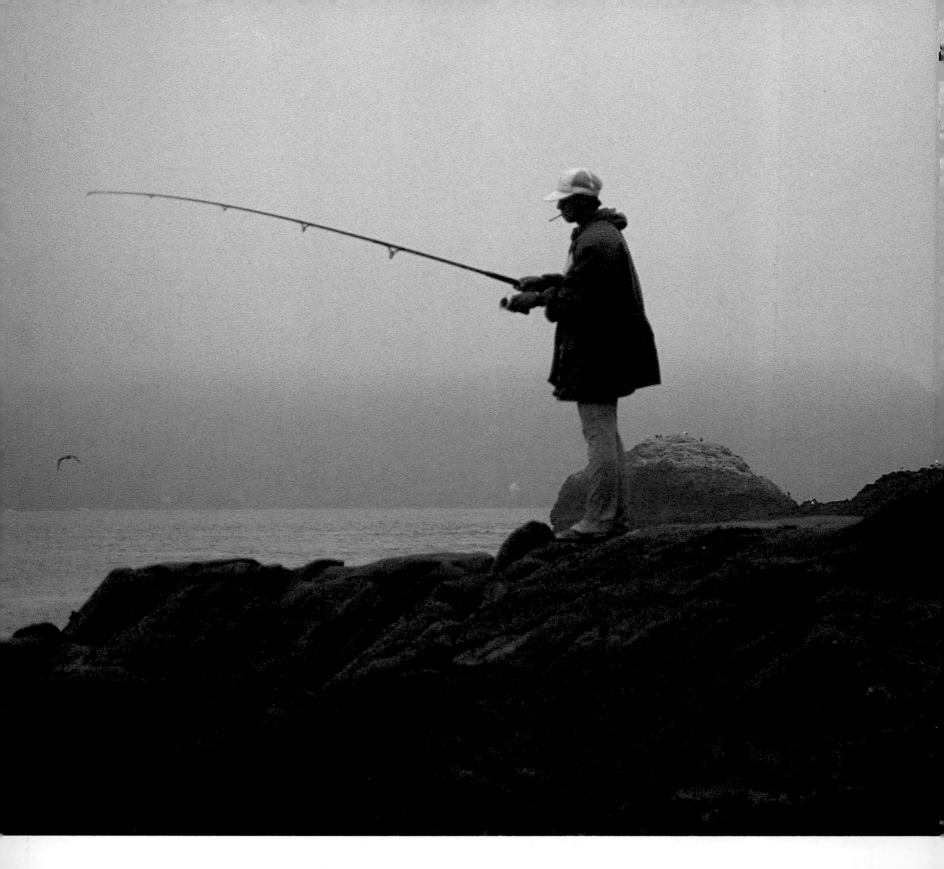

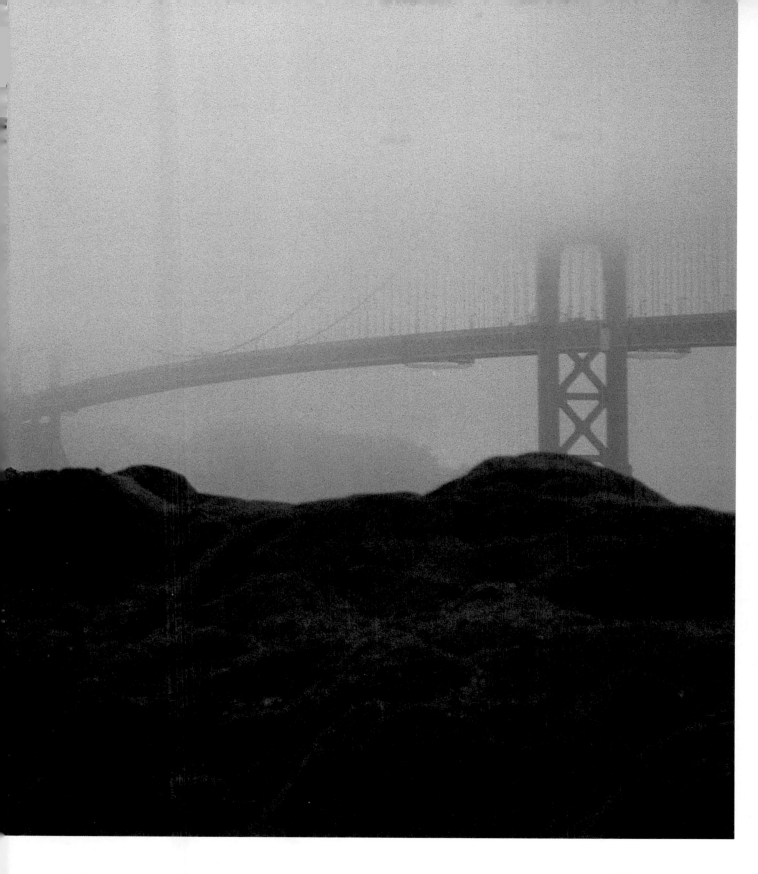

A fisherman waits in the fog at Baker Beach, just west of the Golden Gate Bridge. The blanket of mist creates a natural curtain that encloses the cool city of hills.

ABOUT THE PHOTOGRAPHERS

ROSLYN BANISH is a photographer and author and lives in San Francisco. Her latest children's book, *A Forever Family*, is about adoption.

Photos © Copyright 1995 by Roslyn Banish on pages 6 bottom; 18-19 spread; 22 inset and bottom; 26 top and bottom left; 26-27 spread; 61 top and bottom right; 62-63 spread; 74 top center; 77 top left; 87 left and bottom right; 89 top and bottom right; 97 top; 99 top and bottom; 100-101 spread; 108 inset; 110 top left and bottom; 110-111 spread; 111 right; 113 left; 116-117 spread; and 118-119 spread.

RICHARD BLAIR has been in a photographic frenzy for most of his adult life. Natural and urban landscapes are his first love. He has a studio in Berkeley, but lives in Inverness, California.

Photos © Copyright 1995 by Richard Blair on pages 12; 13 bottom right; 14 top left; 16 inset; 17; 21 bottom right; 29 top; 37 left and top right; 54 bottom center; 74 top right and bottom; 77 top right and bottom; 92 left; 95 top left and right; 100 left; 102-103 spread; 103 inset; 113 bottom right; 114-115 spread; and 116 left.

PETER BOULTON AND EVELYN WILSON have worked together for the past 10 years as travel photographers.

Photo © Copyright 1995 by Peter Boulton and Evelyn Wilson/JEROBOAM on pages 80-81 spread.

PHILIP H. COBLENTZ specializes in "being in the wrong place at the right time" and strives to capture images from the most unusual perspectives. His work has appeared in many publications including *Architectural Digest, Popular Photography, Outdoor,* and *Nikon World.*

Photos © Copyright 1995 CLASSICO SAN FRANCISCO/ Photographer Philip H. Coblentz on pages 28 and 38-39 spread.

GERRY GROPP is a San Francisco-based freelance photographer whose work has been published in *Newsweek, Forbes, The New York Times,* and *Smithsonian,* among others.

Photos © Copyright 1995 by Gerry Gropp on pages 22-23 spread; 70 top; 72-73 spread; and 78 top.

TONI HAFTER lives in San Francisco and specializes in black-and-white fine art photography.

Photo © Copyright 1995 by Toni Hafter/ PHOTOVAULT on page 94.

BILL HANNAPPLE, who makes his home in San Francisco, has been a Bay Area photographer for 21 years. His work was most recently published in *The Magic Sign,* a book about the history of the Las Vegas "Spectacular."

Photos © Copyright 1995 by Bill Hannapple on pages 16-17 spread; 34-35 spread; 37 bottom right; 78 bottom; 79; 88 left; 96; 97 bottom; 104-105 spread; and 114 top center.

ACEY HARPER is a freelance photographer and picture editor who has shot worldwide for a variety of clients. He lives with his family in Tiburon, California.

Photo © Copyright 1995 by Acey Harper/ REPORTAGE on pages 46-47 spread.

DON KELLOGG is a Bay Area photographer with credits that include 14 covers of *California Living* magazine, two International Nikon Awards, and principal photography for The San Francisco Experience on San Francisco's waterfront. Collections of his photographs are held by individuals and corporations throughout the world.

Photos © Copyright 1995 by Don Kellogg on front and back covers; page 13 top; 45 top, bottom, and right; 48; 57; 65 bottom; 82 bottom; and 108-109 spread.

BRUCE KLIEWE specializes in photography that highlights street scenes in the Bay Area.

Photos © Copyright 1995 by Bruce Kliewe/ JEROBOAM on pages 29 bottom and 112.

WERNHER KRUTEIN lives in San Francisco and is the CEO of a visual communications production company. He has traveled the globe photographing a diversity of subjects, from aerospace to Zimbabwe. His work has appeared worldwide.

Photos © Copyright 1995 by Wernher Krutein/ PHOTOVAULT on pages 4-5 spread; 10-11 spread; 13 bottom left; 14 bottom left; 20-21 spread; 30-31 spread; 65 top; 66 left; 66-67 spread; 69 inset; 87 top right; 88 bottom; 88-89 spread; 104 top and bottom center; 106-107 spread; and 113 top right.

MARK LEIALOHA lives in San Francisco and is a photographer of the current rock music scene.

Photo © Copyright 1995 by Mark Leialoha/ PHOTOVAULT on page 51.

FRED LINDEN is a publisher of postcards and a photographer who specializes in images of the Bay Area.

Photos © Copyright 1995 by Fred Linden on pages 43; 52-53 spread; 64; 82 top; 92-93 spread; and 98.

GREGG MANCUSO lives in Southern California and enjoys photographing cityscapes, highrises, and downtown scenes.

Photos © Copyright 1995 by Gregg Mancuso/ JEROBOAM on pages 14-15 spread; 21 top right; and 32-33 spread.

DOUG MENUEZ is a photojournalist and author based in Mill Valley, California, who works on assignment worldwide for a variety of publications and corporations.

Photos © Copyright 1995 by Doug Menuez/ REPORTAGE on pages 49; 50; 58-59 spread; 75; and 107 top and bottom right.

KENT RENO, an ex-pilot and native San Franciscan, has photographed the scope of the City, specializing in images of people interacting with one another.

Photos © Copyright 1995 by Kent Reno/ JEROBOAM on pages 38 left inset and 59 right inset.

JAMES C. SULLIVAN has been called the "fishin' magician" and has photographed in 68 countries. He lives in Santa Cruz, California.

Photo © Copyright 1995 by James C. Sullivan on page 7 top.

ANNE TELFORD is a native Californian who has lived in San Francisco for the past decade. She considers herself a poet-photographer and likes to photograph in cemeteries (stone angels don't move).

Photos © Copyright 1995 by Anne Telford on pages 90-91 spread and 91 inset.

TOM TRACY's work has been published by corporations and in magazines such as *Life, Time,* and *Newsweek.* His work is on permanent exhibit at the Smithsonian Institution and his photographs have appeared in the Time-Life Books Photography Series, including *Photographing Nature, The Sierra: The Great Divide,* and *The Northwest Coast.*

Photos © Copyright 1995 by Tom Tracy on pages 1; 2-3 spread; 6 top; 7 bottom; 8-9 spread; 24-25 spread; 34 bottom left; 40-41 spread; 42; 56; 68-69 spread; 73 center and right; 76; and 86.

NANCY WARNER is a photographer who works in both black-and-white and color. Her images in this book are from a series of photographs made in San Francisco's Chinatown.

Photos © Copyright 1995 by Nancy Warner on pages 83 and 84.

DAVID WEINTRAUB is a corporate, editorial, and stock photographer. He loves San Francisco for its neighborhoods and its cultural diversity and enjoys interpreting the icons of the city in his own unique style.

Photos © Copyright 1995 by David Weintraub on pages 33 top center and bottom right; 34 top left; 36; 44-45 spread; 54-55 spread; 60-61 spread; 71 left and right; 81 right; 85 left; 95 bottom; 104 bottom left; and 106 left.

JOAN WILDER is a freelance travel writer and photographer whose work has appeared in many publications, including the *Boston Globe.* She lives in Scituate, Massachusetts.

Photo © Copyright 1995 by Joan Wilder on page 70 bottom.

We are grateful to the San Francisco History Room of the San Francisco Public Library for providing the historical photos which appear in this book.

Photos on pages 44 left; 54 left; 62 left; 74 left; and 85 right.